£4.99

The Cities of David
The Life of David Norris

Victoria Freedman

BASEMENT PRESS
Dublin

GW00481969

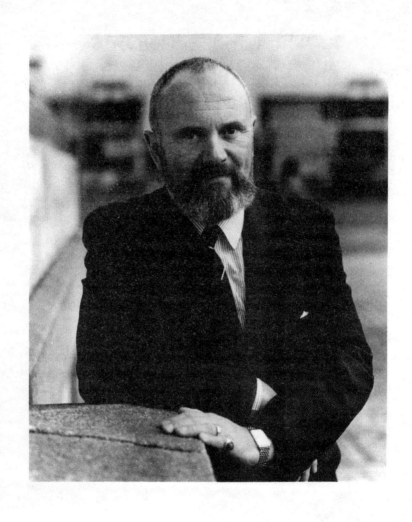

The Cities of David

First published in Ireland in 1995 by
Basement Press
an imprint of Attic Press Ltd
29 Upper Mount Street
Dublin 2

ISBN 1 85594 1 619

A catalogue record for this book is available from the British Library.

The moral right of the author to be identified as the author of this work is asserted.

Cover design: Michael O'Dwyer
Cover photo: Derek Speirs
Origination: Basement Press
Printing: Guernsey Press Co. Ltd

Dedication

*To Bess and Arthur
with love and gratitude.*

A graduate of King's College, London, and post-graduate of Trinity College, Dublin, Victoria Freedman is an award-winning journalist who has written about a wide range of issues for newspapers and women's magazines in Britain and in Ireland.

Acknowledgements

I would like to thank the following people who gave me their time and assistance: Miss Constance FitzPatrick, Mary and John Norris, Susan Paul and David FitzPatrick; Ezra Yizhak, Isaac Mesillati and Michael Moran; President Mary Robinson; Edmund Lynch, Kieran Rose, Bernard Keogh, Brian Murray and Junior Larkin; Senator Shane Ross, former Senator Brendan Ryan and Senator Joe O'Toole; Michael O'Toole, Tom Hyland, Ken Monaghan, Enda Dowling, Miriam Gordon, Frank McDonald, Josephine O'Connell, Helen Perry and Jean-Claude Carlier.

The following books were extremely useful to me; *Sex, Death and Punishment* by Richard Davenport-Hines (Fontana), and Kieran Rose's *Diverse Communities* (Cork University Press).

And grateful thanks to everyone at Attic/Basement Press, especially Róisín Conroy and my editor, Ríona MacNamara. Most of all I would like to thank David Norris for making this book a pleasure to write.

Basement Press, would like to thank Derek Speirs for unearthing photographs from his archives and The *Irish Times* for the photograph of David Norris with Dean Victor Griffin and Noel Browne. We would also like to thank the following, for their help and time in completing essential detail around various other photographs; Kieran Rose, Tony Gregory, Murrough Kavanagh, MacInnes Photography and John O'Neill of the Buddist Centre at Kilmainham Well House in Inchicore. All other photos belong to David Norris's private collection.

Contents

List of Illustrations

Cover photograph: Derek Speirs
Inside cover: private collection

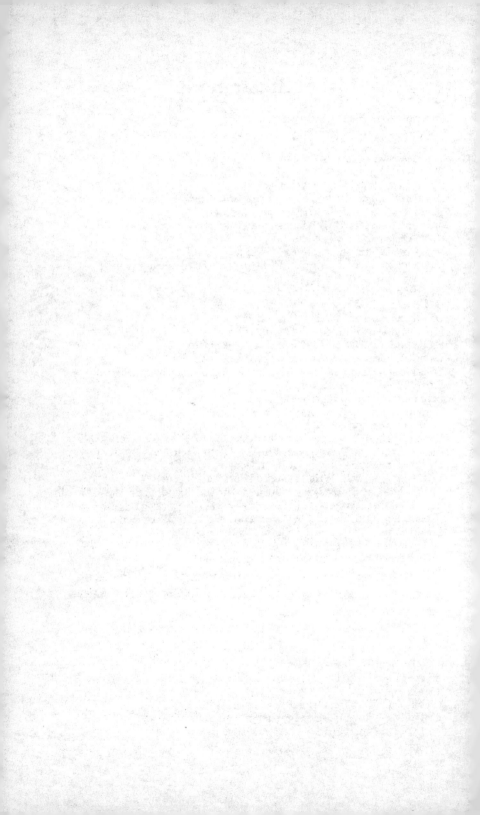

INTRODUCTION

Short and portly, the buttons of his suit waistcoat straining over his chest, cropped silver hair, bushy beard, small eyes surrounded by warm, crinkly laughter lines, kind smile, white even teeth, booming voice - quite high, sober in pinstripes ... David Norris held open the door of Kildare House, stopped at the top of the steps and suggested that the meeting to discuss this book take place at a little coffee shop nearby.

So far, so senatorial - until he placed his backside on the rail and, with his hands flapping in the air, slid gaily down to street level.

An obvious regular in the café, he greeted staff and customers, sat on a stool and lit the first of the three cigarettes he would smoke in thirty minutes.

He was flattered by the request to be the subject of a book, but feared others would think a biography immodest, and was anxious that neither friends nor family be hurt by any revelations.

It was June 1994. A few months later, after a few gentle reminders, he suggested more discussion over lunch at Leinster House. No wine - since contracting hepatitis, he had been ordered by his doctor to avoid alcohol - but he could not resist the rich chocolate dessert. Health, Hebrew, travel and travellers - he was an enjoyable conversationalist and interesting company, and as lunch came to a close, he agreed to recount his life story.

Because of commitments, ill health and travel, it was not until a few months later that the first of many meetings between us took place in his house in North Great Georges Street - four storeys, home to a couple in the basement, a sitting tenant on the ground floor, another apartment with a roof garden on the top floor, an office, and David Norris. A little plaque on the heavy front door reads 'Private Residence. Visitors by Invitation Only'. The hall is long and high, the splendour of the original Georgian decoration beautifully revealed. Hessian covers the stairs. On the first floor a drawing room and dining room - imposing, almost stately. Portraits on the walls above fabulous fireplaces, a polished piano on which are carefully placed family photographs. Perfectly fitting period furniture. To the floor above and the little flatlet where he lives - a small sitting room with a large oval table, in the middle a bowl of hand-painted eggs collected on his travels around the world. Pictures of his love, Ezra, and African hand-carvings of animals in wood. A tiny settee with a red throw from Cairo; behind folding doors a hideaway kitchenette. His bedroom is modest, with space enough for a small desk and a high brass bed, adorned above with voile curtains and with cherubs. Next door, a little dressing room with a rocking chair that belonged to his grandmother. In the bathroom some sexy, modern male pin-ups.

While the tea was brewing in a pot kept warm with a cosy, he flicked through a vast pile of post and excused himself - there were a few calls to make.

He returned, set out a plate of biscuits, hunted for some sugar, poured out the tea and began to reminisce. Meetings would always be thus initially delayed, accompanied by tea and frequently interrupted by Tom, the builder, still working on various parts of the house. 'If everyone in the world were like David Norris, we would all be happy. He's the nicest, most sincere man I have ever met.'

The telephone would ring. If mildly harrassed, he would listen to the message on the answerphone and then dash to respond; if feeling relaxed, almost high, he would pick up the phone immediately. 'Hello! Mr Norris's residence. Butler speaking ...'

David Norris was never anything but generous, good-humoured, highly entertaining and very amusing. He was always kind, considerate and very obliging. Despite others' accusations of a wicked, hurtful wit, he spoke always with love and care. He once remembered that as a schoolboy he had sat in the classroom and clapped his hands in glee when the teacher announced a half-day holiday. It prompted a cutting remark about his childishness, a remark that still hurts today. He is clearly a sensitive man hidden behind an exterior that is brash and sometimes crass.

As we spoke, he was not shy about recounting his achievements, but only those in the context of political dexterity or necessary social intervention. Any personal self-congratulation seemed to be simply the need of a man without a partner, with no one to bolster his ego.

David's relationship with Ezra, an Israeli, was almost in its twentieth year. David brought Ezra into the conversation at any opportunity, mimicking his accent with affection, and at each meeting recounted their latest weekly telephone conversation. Without doubt, David's life hangs emotionally on Ezra. It was immediately apparent that David loved Ezra very deeply, but perhaps needed reassurance that the level of his love was requited. David's practical life revolves around his aunt

Connie, now ninety-seven. Even those carers with the biggest of hearts sometimes complain, but David always spoke about her with fondness and concern.

His time is limited. But unfailingly generous and incessantly busy, too busy for one who has had hepatitis, he gives portions of it to everyone.

There is only one troubling element about David Norris. Ezra has said that David will always 'think pink', and indeed he seems ludicrously sunny despite the obvious hurts and disappointments he has suffered. His life has been eventful and rewarding, but the suspicion lingers that he is lonely and lacking in love.

It is a personal wish that David Norris enjoys good health and contentment. He is a wonderful man.

Victoria Freedman
August 1995

CHAPTER ONE

The Congo

The boat was as black as the sea depths and the winter sky, slowly skulking across an Atlantic still inhabited by enemy submarines despite the imminent end of the war. For the middle-aged woman travelling alone with her six-month-old baby boy and four-year-old son, it was a long, grim, perilous voyage. She cradled the baby in one arm and clutched the boy with her free hand as, from time to time, bursts of gunfire, sudden, loud and frightening, echoed around the boat. There was danger on deck, discomfort down below, darkness almost everywhere. Long gone was the bright blistering sun of the Congo where she had been so blissfully happy for the past fifteen years.

For two weeks, the blackout devoured the days. It was a voyage of nights that seemed as infinite as the horizon. As the boat neared Britain and Southampton finally came into view, Aida Norris, cold and exhausted, was greeted by unwelcoming grey sheets of rain, but was grateful to be safe, and utterly relieved by the sight of her brother, Dick, in his army uniform, standing amongst the crowd that had gathered on the docks. Thankfully accepting the hot, sweet tea supplied by the Canadian Red Cross on disembarkation, her spirits rose. Soon she would be back home in Ireland.

Aida Margaret Norris was forty-four that day in 1945 when she came back to County Laois with her sons John and David. It was intended that her husband John, an engineer employed by Lever Bros, would work out his contract in the Congo and join them later. David Norris's mother, Aida Margaret, was one of four children raised in Mountrath, a small country town about sixty miles from Dublin. Her father, John, was a FitzPatrick, one of a Protestant Irish family that had descended from Giolla Phadraig, the fifth-century ruler of the ancient kingdom of Ossory.

In 1873, when John FitzPatrick was one year old, his father, Richard, a landowner, died from lead poisoning, having inhaled fumes from the paint he was using to redecorate his house. The inscription on the obelisk over his grave, written by his friend Captain Stannis, the grandfather of the ballerina Dame Ninette de Valois, reads:

To an intelligent mind was added an honest and upright heart. He was religious without show, charitable without profession and liberal without ostentation. Reader go thou and do likewise and your end will be peace just as his was.

John, orphaned barely a year later when his heartbroken mother, Margaret, passed away whilst visiting her husband's grave, was raised by an old aunt, Mrs Dobbs, who believed that strict discipline without unnecessary kindness was the best way to bring up a boy. While his sister was sent to Alexandra College, a private school in Dublin for young ladies, and later became governess to the Gore-Booth daughters, who inspired Yeats's poem 'Lisadell', then to a wealthy widowed landowner in Argentina, John FitzPatrick was educated at home, and for the rest of his life remained in Mountrath.

It was a small country town, once quite prosperous owing to its cotton and brewing industries, until its inhabitants, fearing that the arrival of the railways would bring chaos to their midst, refused to allow the lines to pass through the town, thus considerably diminishing their own financial prospects.

Richard's own father John (David's great great grandfather), though a descendant of another John FitzPatrick last Earl of Upper Ossory, was legally evicted from most of his property by his own godfather, Sir John Scott of Angrove Abbey. This inevitably precipitated a decline of family fortunes. Indeed David wryly described the FitzPatrick's from this time on as having joined the ranks of the 'Descendancy'. John, Richard's son and David's grandfather, eventually inherited two farms, the larger of which called Green Hills was situated just outside the town. There he settled down to life as a farmer with his wife, Margaret, a beautiful woman from nearby Maryborough (now Portlaoise), who shared his sense of mischievous humour and later became known to David Norris as Granny Wiz.

At the start of their married life John and Margaret lived in a largish Georgian house with bowed ends called 'Spring Gardens', just outside the town. The house has since been demolished to make way for a council estate. They had four children - Dick, Connie, Aida and David - and lived not on the farm but eventually in the Old Post Mountrath. Times were tough - cows had to be sold off, money had to be found from other sources - so John had become the town's postmaster. Later when Chaplain to the Brigade of Guards, Dick became friendly with Queen Mary and Princess Alice Countess of Athlone who organised a tapestry circle to make kneelers for the Guards Chapel. On one occasion the old Queen asked 'and Mr. FitzPatrick what exactly does your father do?'. Uncle Dick replied laconically, 'he's a postman Ma'am.'

John's grandson, David FitzPatrick, remembers spending his holidays on the farm during the war, when

he was a small boy, after his father had moved from Mountrath and settled in Dublin. They would board a red and white country bus from the busy terminus at Arran Quay, full of bag and baggage being transported around the country, and set off by the Liffey, watching the Guinness barges travel up and down the river, taking their goods to ships bound for Liverpool. The three-hour journey to Mountrath was haltingly slow, as the bus stopped several times en route, whereupon all the men would get off. It was not until much later that David realised that every stop was a pub and that the men were all relieving themselves or getting more drink.

The house itself, now Rourke's chemist's, still has the counters used when it was a post office.

'I remember the house had a big brown door, a window on one side, a shop window on the other, and long, brown counters, the actual counters used when it was a post office. You went into the house and the dining room was on the left-hand side - quite a nice room with a big, leather settee. Then on the right side was a door which went into the shop where there were all sorts of exciting things like weighing scales.'

In those days before rural electrification, the house was lit by paraffin lamps and candles, and heated by great open fires made with the excellent turf that came from the surrounding bogs. David FitzPatrick's aunt, Miss Connie FitzPatrick, at the age of ninety-seven, remembers how her mother, fond of building up a blazing fire, would often set the three-storey house alight.

They may have lived in a grand house, but the FitzPatricks struggled for money and, during really lean times, John would become the town auctioneer. But although impecunious, they saw no reason for despair. After all, they had a coat of arms and a family motto - *fortis sub forte fatiscet*, 'the strong yield to the stronger' - for they possessed a sense of lineage, of pride, of their own distinction, and of their own Irishness. Certainly, they revered the monarchy, but the only concession to

British rule had been to change their name from Mac Giolla Phadraig to FitzPatrick in order to meet with the establishment. This desire to blend in was not a trait that John's other grandson, David Norris, would inherit.

David's attitude to money, however, has always been similar to that of these FitzPatricks, who were quite untroubled by times of diminished means. This stance must have skipped a generation, however, for John's two daughters, Aida and Connie, held a lifelong fear of buying on credit or being in debt to a bank.

Although John FitzPatrick sometimes found it hard to make ends meet, his children were happy. They had each other's company and the freedom of the countryside. Making their own amusement, they would ride their donkey, take out the pony and trap, play tennis and spend sunny days in the fields with their father. They were close to their parents and the house had a sense of fun. As an adult, John was a well-read, witty man, who with appropriate melodrama would tell his children tales about leprechauns or recite reams of poetry.

David Norris may have inherited some of his grandfather's temperament and certain of his other characteristics, but most certainly he was influenced by, and according to a cousin may have modelled himself on, his uncle Dick, the eldest of the four children, who is fondly remembered by all his surviving relatives.

Though money was always short in the FitzPatrick household, a good education was seen as vital. Dick was initially sent to King's Hospital school in Dublin, which he hated. Convalescing at home after contracting pneumonia, he refused to return to school, and instead completed his secondary education at the monastery in Ballyfin, then joined the British army during World War I. He was given a recommendation by his tutor the Revd. Sir John Pentland Mahaffy who had much earlier been Oscar Wilde's tutor at Trinity.

Provost's House
June 12th [1916?]

Dear General Fry,

 This is to introduce an excellent youth, highly educated man who wants a transfer from the A.S.C to the field or garrison artillery. His case is very good. Please do what you can.

Yours
J.P. Mahaffy

Dick's nephew, David FitzPatrick, who always held images of his uncle fighting in the trenches, was disappointed when he later discovered that Dick had in fact been stationed in the County Dublin port of Kingstown, now Dun Laoghaire. Nevertheless, there was great pride in Mountrath when he returned home as Sergeant Dickie, and over the years he did travel a great deal, to Palestine, to Malta, to Egypt ... from whence he would send home a torrent of entertaining correspondence detailing his exploits.

After the war, Dick distinguished himself at Trinity College, Dublin, where he read moral sciences, and on graduation entered the Church of Ireland. He later rejoined the British army, this time in a religious capacity, for he went on to become chaplain to the Brigade of Guards in London, then honorary chaplain to the Queen. It was a perfect job for one from such royalist stock.

'He believed in horses, the royal family, and God. In that order,' remembers David Norris.

The youngest son, David, who loved the country, wanted to take over Green Hills but his parents refused to allow him to become a farmer. Their own experience of battling to make money here and there, had proved it was an unstable life, too dependent on outside elements, so after his education was completed, first at Preston

College in nearby Abbeyleix, then Wesley College in Dublin, David found a job in the Bank of Ireland, which pleased his family immensely. He settled in Dublin, where he married Jean, the daughter of a civil servant, and had two children, David and Susan.

Miss Connie FitzPatrick, the eldest daughter, now David Norris's oldest and closest surviving relative, attended a small, private school in Abbeyleix, then Wesley College. During the war she stayed at home in Mountrath, but she later found a job in England as a companion to people called Barrow, cousins of the Cadbury family.

Although Miss FitzPatrick enjoyed herself there, especially relishing the weekly treat of visiting the Bourneville factory, the job was shortlived. Dick, now a chaplain was in London; David was in Dublin, Aida too. It was left to Miss FitzPatrick to return to Mountrath and look after her parents, earning her living as a legal secretary in a local solicitor's office.

Despite inheriting her mother's beauty, elegance and figure, Miss FitzPatrick insists still that she was a plain Jane and that it was her younger sister, Aida, who had all the boyfriends. Also sent to Wesley College as a boarder, Aida then spent two years at Alexandra, but her life took an unexpected turn after she fell in love with an Englishman called John Bernard Norris.

John Norris, David's father, was born in Richmond, Surrey in 1896. Later his family moved nearer London to Hounslow, and by the 1930s were living in a fine house in Ennismore Gardens, Knightsbridge, an area of the capital that is still fashionable and expensive today.

John's father, also called John, had followed the family tradition of serving in the British navy, and eventually had joined the Corps of Queen's Messengers, becoming a 'silver greyhound', one of the small and elite number of diplomatic couriers who carry the most secret messages of royalty and government around the world.

David's father John Norris had a similarly distinguish-

ed career; he was decorated a number of times when serving in the merchant navy during World War I; on one occasion he had brought in a ship, the *Sceptre*, that had been crippled in a submarine attack. Many of the crew were killed or injured when the boiler exploded; some were burned alive, and like snakes, shed their entire skin. John Norris must have been injured, too, at this time, for he later walked with a slight stoop. A photograph of him from this period shows a tall, thin man with a keen, yet kind, innocent expression in his large eyes.

Little was known about John Norris's family until fairly recently, when David Norris discovered that his father had two brothers and three sisters, all now dead. It appears that each side of David's family, for a strange but inexplicable reason, looked upon the other somewhat disdainfully, and after John married Aida there was little contact between them.

One of John's sisters, Lena, married an American and in a letter she wrote to her brother mentioned another sister, Daisy, who had died of cancer at the beginning of the war.

There was a brother called Charlie, about whom nothing is known, except that he was a handsome, generous man and he had been boxing champion of the RAF, and another brother, Maxwell. Some time in the mid 1970s, David, fond of jazz music, was listening to the radio when he heard Humphrey Lyttleton play a record for an old friend, Maxwell Norris, who lived in County Wicklow. Excited by the possibility of discovering a relative whom he had not known existed, who could even be living up the road - for at the time David himself was living in Greystones in County Wicklow - David turned detective. After tracking down the man's widow, it transpired that Maxwell Norris was indeed his Uncle Max. He had been educated at an English public school and settled in Wicklow after another sister had married an Irishman.

Despite the estrangement of his parents' families, it is

curious that David was unaware he had an uncle who lived in Ireland, for not only was Maxwell a gardening correspondent for the *Irish Independent* newspaper, but his interest in all kinds of Eastern material once led to a demonstration of yoga - he stood on his head - on *The Late Late Show.*

David's correspondence with Maxwell's widow was shortlived, and she was not interested in meeting him. However, her letters, written in wonderfully Gothic prose, were entertaining, if unenlightening: 'It is now some sixty years since I entered the enigmatic circle of the Norris family, with their dark and terrible secrets ...' she wrote.

The nature, or even existence, of those secrets remains a mystery, but David was able to discover, perhaps with a certain amount of disappointment, that his father's mother was not a baroness as he had earlier been led to believe.

'On the other hand,' wrote Uncle Max's widow, 'her mother certainly was, although I do not believe that minor European titles descend in the female line.'

Miss FitzPatrick, who rather scorned the Norris family lineage, was not impressed. 'It wasn't a real title, was it?' she protested to David. 'It wasn't British. They handed those things out like confetti in Europe. They mean absolutely nothing. And in any case, one good look at your grandmother's nose would tell you exactly what she was - a Middle European Jewess!'

David, who by this time had fallen in love with an Israeli and become more than enamoured with all things Jewish, was delighted.

He retains just one recollection of his father's mother, Juliette, who seems to be the only relative with whom the family had any contact.

'I thought she was rather severe,' he says. 'I was four, and she was a regal old lady sitting up in bed. I wanted to run and look out of the window at trains and she reprimanded me. I remember my father saying, "He's

only a little boy.'"

In the late 1920s John Norris, like his brother Maxwell, had come to Ireland to visit a third sister who was married to an Irishman called Montgomery-Martin. It was then, at a game of tennis, that he met Aida, and soon after the couple announced their engagement.

'I was very surprised,' remembers Miss FitzPatrick, who was five years older than her sister. 'She was very attractive and had lots of boyfriends, and I couldn't say what she saw in him - John was a very quiet man and it wasn't easy to get to know him - but she certainly saw something because he was the one she wanted.'

Aida was twenty-nine and John thirty-four when they were married at eight o'clock on the morning of the 10 of September 1930 in St Ann's Church in Dublin's Dawson Street. The only members of Aida's family to attend were her parents and sister Connie; a cousin, Mabel Chapman, although apparently uninvited, scuttled into the back of the church at the last minute. After the wedding the couple set off directly for Torquay, where they spent a short honeymoon before heading to Africa, to the country that is now Zaire but then was known as the Congo. 'She was very much in love with my father,' explains David. 'It was a great romance and a great adventure.'

After the war, John, who combined a creative ability with a scientific training and was an enthusiastic inventor, had started up a small company called the Thrale Engineering Company to produce the hydraulic lifts he had designed. Little is known about the business, except that it failed and John went to Egypt to work for a big oil company as a marine engineer.

Now he had accepted a job as an engineer with Lever Bros. in the Belgian Congo, and it was to this African country, a huge, hot and humid area covered by rainforests, savannas and highlands, a country that had experienced a long history of slavery, economic exploitation and abuse, a country whose peoples were mostly uneducated and engaged in tribal conflicts, that the

newlyweds came in 1930, initially living in the bush as John's work involved the harvesting of palm nuts for the oil used to make soap products. On arrival, Aida and John were greeted by the mother and father of all thunderstorms and could only find their way to their accommodation with the aid of the light provided by the electrical thunderstorm.

Although her parents worried whether Aida, a country girl who had only ever been as far as London in her life, would settle in such seemingly uncivilised surroundings, the following fifteen years spent by the great snake river were to be the happiest their daughter had ever known.

'She loved it,' says David. 'She used to describe to me the boats going along the Congo - she loved the river - and she'd go out into the Bush and collect animals which she would bring back to her house.'

One of these rare and exotic creatures was a Herman's Potto, a sloth-like animal which became the first ever kept in captivity when Aida later brought it back to England and presented it to London Zoo. It earned her lifelong membership of the Zoo, the friendship of Sir Julian Huxley and a photograph of the animal sitting in the zookeepers hat appeared in the London *Evening Standard*.

Later John and Aida moved to the city of Leopoldville, now called Kinshasa, where, like many Europeans, they enjoyed an extravagantly luxurious lifestyle far removed from what they had known in Europe, with several cars, chauffeurs, maids, gardeners and, eventually, a personal servant for the first son, John. A photograph taken at this time shows David's older brother looking like Little Lord Fauntleroy, as if he lived in an English country house rather than the hot Congo.

But Aida Norris was quite different from many of the other Europeans in the colonies. Instead of leisurely basking in her comforts, or following the tradition of the lady philanthropist, she put much effort into educating

27

her servants. Mostly from quite primitive backgrounds in the Bush - no secondary schooling was available for the Congolese until the end of World War II - they became extremely fond of their employer.

Aida also became fluent in French, and by laboriously writing down all the words phonetically even taught herself Kikongo, one of the four languages used by all the different ethnic groups in the Congo.

Her husband, too, enjoyed living in Africa despite the hard work in the hot climate, but the couple always looked forward to their visits home whenever John was able to take leave.

'Later he used to fly, but in the beginning they went by boats which seem to have been terribly luxurious,' says David. Even the food on board ship was exquisite. Although several were destroyed in a flood in his house, David still retains some of the beautiful postcards, carefully collected by his mother, that were attached to the menus.

'They were different each day, and if the main item on the menu was a Chinese dish, the postcard was Chinese. And for the first course there were about eight different kinds of egg dishes. The choice was incredible.'

Their very last journey home was to be very different.

Life in the Congo did have its risks, however, and for some time Aida was incapacitated by rheumatic fever. Whether that illness delayed the start of a family is unknown, but certainly after nine years of marriage, the family back home in Ireland were surprised to hear of the birth of a son, John, in 1940.

David was born four years later, in the Clinique Reine Elisabeth in Leopoldville, on 31 July, at one o'clock in the afternoon - 'which,' he reasons, 'accounts for my sunny disposition and appetite for food.'

He was six months old when it was decided that his father would take early retirement and the family would return to Ireland; not only had they been unable to make a visit home since the beginning of the war, but working

in the Congo had taken its toll on John.

After hearing there was space on a boat setting out for England, Aida hurriedly gathered a few belongings together and left the hot continent of Africa with her two sons, bound for England and, eventually, home. John would work out his notice for Lever Bros., pack up and rejoin his family later.

The *Copacabana* may have sounded like a cruise ship but it was a cruel voyage that brought David Norris to Ireland.

Dublin 4

David put his little hands flat against the french windows which opened on to the garden, pressed his face to the glass and stared longingly at the snow that lay thickly on the grass and decorated the plum, pear and apple trees. He was three years old, and very cross with his mother who had forbidden him to go out and play. Worse still was the spectacle of the children from next door running around in his snow - in *his* garden. David listened to their shouts of excitement, and watched from behind the glass while they turned the pure, exquisite snowscape into dirty, grey slush.

From that early experience, feels David Norris, came a lasting sense of injustice; fortunately it was accompanied by great moral courage, for he was also determined to fight unfairness.

Although reasonably strict with her sons, Aida was not wilfully depriving her son of the chance to play in the snow; she was simply still following the advice of a doctor in Mountrath who believed that a baby born in the tropics should be kept in the warm, in a room with a constant temperature, to avoid catching colds.

The change in climate had indeed been brutal. After spending a few days in London, Aida had taken another sea voyage. This had been short and there had been no threat of enemy gunfire, but it had been cold and damp on the mail boat that crossed from England to Ireland to arrive at Dun Laoghaire harbour in County Dublin.

The weather may have been unwelcoming but to be back among the family was heartwarming. Initially Aida and her children stayed with Aida's younger brother, David, who lived in Dundrum.

His son, David FitzPatrick, then aged eight, had never seen his aunt and two cousins before, and still recalls the tremendous excitement felt by his parents.

'And I remember that Aunty Aida brought oranges with her. I don't think I'd ever seen an orange because you couldn't get them during the war, but these had been green when she left the Congo and they weren't very good by the time she arrived.'

Aida, John and David then moved on to Mountrath where her sister Connie, Miss FitzPatrick, was living with her mother, Granny Wiz, now a widow. John FitzPatrick had died, aged eighty, just before Aida's return home; he never saw his two grandsons.

Although Aida must have felt keenly the loss of her father, and certainly she missed her husband desperately, her wicked sense of humour was certainly intact, as Miss FitzPatrick found out. 'At one point an old aunt was staying with us. Aida had brought home some awful, big horrible-looking insects, and she put one into this old aunt's bed. It terrified the life out of her.'

Today Miss FitzPatrick remembers David as a very puny baby who was mostly kept in the warm drawing room. Despite this and later cosseting, David Norris was to suffer pneumonia twice as a child and again when he was twenty-one, at one of the most devastating times he was ever to experience.

As a baby, he was the *enfant gâté*, treasured and spoiled by his Granny Wiz. She called him Bumble, because of a striped jumper he sometimes wore, which reminded her of a bumble bee and like many childhood nicknames it stuck. David became known to the whole family as Bumble until he was old enough to dislike it.

The stay at Mountrath lasted a year, as it took that long for John Norris to get leave from the Congo. Not only was he highly valued by Lever Bros., but the governing authorities in the Congo also found him very useful; as a professionally qualified white man he had taken on the role of local magistrate and become arbiter of many of the disputes among the Congolese. His contribution during the war, keeping supplies going to the Allies, had further kept him occupied and as in World War I, his efforts were recognised; he was later knighted by the King of the Belgians who made him a Chevalier of the Order of the Lion. All his medals are proudly kept by his younger son, and like Uncle Dick's decorations, leave their box only for fancy-dress parties.

Finally, however, John Norris was able to take time off and rejoin his family in Mountrath. It was a relaxed and happy time, remembers Miss FitzPatrick, although fleeting. Intending soon to retire, return to Ireland for good and perhaps enter politics, John Norris bought a property in Sandymount, Dublin 4, and after settling in his wife, five-year-old son and the baby he had hardly come to know, reluctantly returned to Africa, leaving David with his earliest memory - that of watching his father ride off on his bicycle to Friar's in Ballsbridge and arriving back with a two-bar electric fire.

The house in Sandymount, one of four substantial detached properties in a cul-de-sac called Wilfield Park, was empty, uncarpeted and cold, as Aida waited for furnishings to arrive from the Congo. Eventually, though, it was to become a comfortable family home, smelling of polished wood, and in winter diffused with a warm, welcoming yellow light.

Mostly Aida was alone with her sons, who were by no means little angels. More than once the police were called after David, determined to have an adventure, having ignored the strict geographical limits set by his mother, rode out on his tricycle and became lost.

His best friend at this time was Michael Moran, who lived two doors away. Today Michael remembers how a cleaning lady who had worked for Mrs Norris described the current senator as a 'jungle boy'. 'Once Mrs Norris went out shopping and she was left to look after David. She said he walked along the bannister at the top of the stairs as if it was a tightrope, with a knife in his hand. It was fairly typical. He was quite wild as a boy. His mother was a beautiful woman, soft and gentle. I don't know how she managed to keep the two of them in tow when they were young.'

Aida's husband John, still waiting to retire, was away for lengthy periods and came home only on leave. Miss FitzPatrick says John always fitted in with the family very quickly on his return and was anxious to spend as much time with his sons as possible. But they were never really to know him, and their memories of him are few and understandably unaffectionate.

'I can barely recall what he looked like,' comments his oldest son, John. 'I remember getting a Meccano set every Christmas, and on one of his visits home, I remember him buying a car, a Ford Zephyr, and being abominably sick in it. Also that he sold it again before returning to the Congo - it was cheaper to do that than leave it in Dublin unused.'

David can recall only lying down with his father when he took an afternoon nap - then waking him up almost immediately with his fidgeting, and a holiday in Ballybunion in 1948 when his father played golf and went swimming.

'He was a tallish, thin man, who wore brown Harris tweed suits,' remembers John's nephew, David Fitz-Patrick. 'He was tanned but rather grey-looking. He

never looked terribly well and in fact he used to get malaria quite a lot. But I shall never forget the day he died because of the upheaval. I must have been fourteen and I remember my father being called to the house next door because we didn't have a telephone, and cycling off to Sandymount. Aunty Aida had just heard that John had died.'

Aida might only just have officially heard that John was dead, but she had understood it some days earlier after receiving a telephone call, and then a telegram, expressing concern that he was ill. If the intention was to break the news to her gently it was unsuccessful; her oldest son, John, then aged ten, also knew instinctively after the first telephone call that his father was dead.

Nevertheless, Aida called her boys into the dining room to explain that their father would never again return on leave.

'I remember her standing in front of the fireplace, and saying that there was only the three of us now and that we'd all have to stick together,' says David. 'Of course my brother and my mother were crying, but I found it extremely difficult to squeeze out a few tears, which I felt were required. It meant absolutely nothing to me. I hadn't seen much of him, and at six years old, didn't know what it meant at all. I was far more upset that we wouldn't have a car now.'

He was later to learn that John Norris had died, aged fifty-six, from a coronary thrombosis.

'I think my mother felt he worked himself to death,' says David. 'Afterwards she didn't talk a huge amount about him. She certainly loved him very much and had the highest regard for him and his standards in life. And they were a good team together. When they were first married, my mother encouraged him to continue studying engineering at night which resulted in a string of letters after his name, and she was instrumental in his very distinguished career.'

Aida's experience in the Congo had already proved

her a capable woman. Now she had an even greater task on her hands - to bring up two young boys alone.

Financially, things were tight but not hopeless. Aida received a widow's pension from Lever Bros., and there were also regular payments from the Belgian government - payments which required occasional trips *en famille* to the Belgian embassy to prove that the Norris family was still alive and still needy.

Certainly there was sufficient money for food, most of which, in those days, was delivered to the house - groceries from Leverett and Fryes and Findlaters in Sandymount, bread from Johnson, Mooney & O'Brien, and fish from Sawyers in Grafton Street. Aida put it all to excellent use, for she was a superb cook.

Soon after John died, Granny Wiz and Miss Fitz-Patrick left the Old Post House and moved to Dublin, staying first with David FitzPatrick and his family, and then for a while with Aida and the boys before settling in a manse house by the Presbyterian church in Dun Laoghaire.

Granny Wiz was adored by all her grandchildren despite being extremely strict. Newspapers were not allowed in the house on Sunday - even playing was not allowed on Sunday. The day was spent reading the Bible or taking 'improving walks' during which the boys would learn the names of trees.

Granny Wiz died in 1955, and this time David was old enough really to feel the pain of loss. Even now he cannot listen to the hymn 'Abide with Me', which was played at her funeral, without feeling a great sadness.

Miss FitzPatrick, too, was much loved, especially by David, although she was also a strict disciplinarian and far more direct and outspoken than the soft and gentle Aida. Later, when she came to visit, Miss FitzPatrick would chide David if he was playing instead of working.

'She didn't mince her words,' remembers Michael Moran. 'She'd tell him, "You'll never get anywhere, you'll end up nothing ..."' When she'd gone David would say

"Silly old bag", but he clearly loved her.'

The boys were not spoiled, for Aida set rigid rules which when broken earned them a few strikes with a bamboo cane. They were forbidden to read comics, save the *Eagle* and *Classics Illustrated*, which featured in pictorial form the novels of authors such as Sir Walter Scott.

The wireless, which was placed in a window recess in the dining room, was not for the children's use until David managed to persuade his mother to let him listen to *Children's Hour*, with Uncle Mac and David Davis, on the BBC; the programme had previously been banned as it clashed with their five o'clock supper. Later, if his mother discovered David listening to such unapproved broadcasts as the still subversive Radio Luxembourg or *Dick Barton, Special Agent*, she would turn the wireless off smartly.

Lunch, in the dining room, was at one o'clock sharp; bedtime at seven o'clock, much earlier than the bedtimes of the other children in the road. Some of the rooms in the house were locked to keep them tidy and clean or to prevent the boys from rummaging through their father's papers.

It was a correct and formal upbringing. There was little display of physical affection, and politeness was paramount. One certainly did not engage in conversation about politics, religion or sex, for fear of causing offence, a stricture David Norris has diligently ignored since reaching adulthood.

However, the children were very much loved and the atmosphere in the home was happy, mainly due to Aida's irrepressibly jolly nature.

A large woman who lumbered rather than walked, her legs swollen by the rheumatoid fever she had contracted in the Congo, she nevertheless made every effort to take the boys on picnics or on trips; most exciting was catching the train at Sandymount and going to Dun Laoghaire baths, where they would buy a

sixpenny slab of Cleeves toffee.

Mostly, though, John and David played by themselves, although with a four-year age difference they had little in common. As their cousins Susan and David FitzPatrick remember, while John was quiet and reserved, David was energetic and bouncy.

John was the typical older brother, and in David's eyes he was worthy of unreserved hero-worship, as well as admiration for his prowess in sport. Yet David was often irked by John, for his older brother always won their arguments - John was one of the few who would ever win verbal battles with David.

The boys kept rabbits, dogs and a cat, and to this day John and David each feels he had the superior love of animals. According to John, it was David who was to blame for the rabbits being drowned. The younger boy would forget to cover the outside toilet with gauze, and the rabbits would frequently be discovered, their little corpses stiff and their legs sticking out over the rim. Once, John says, he walloped his younger brother for waving a kitten around by his tail.

According to David, John loved animals but only to the extent of extracting affection from them; whenever Tom, the cat, was bitten below his right ear, a regular occurrence seemingly, David says it was he himself who took him to the vet to have the festering wound cleaned, and that it was he who took the two dogs, Nip and Patch, for walks or to the vet when they were poorly, and who cleaned out their kennel.

The relationship between the brothers was good if not unusually so, but David spent most of his time with Michael Moran, who had not only a father but a motor car as well - *and* a sandpit, where the two boys would play with their Dinky cars, perhaps the brand-new Schuco car that David had received for Christmas. The Morans also had an air-raid shelter, which became the headquarters of the AUS (the Adventurers' Underground Society), the two members of which went out on 'raids',

climbed over fences and looked into people's windows.

'David was absolutely fearless,' says Michael. 'If there was frosty weather we would play on the slide with the other kids from the road. The idea was to wear the leather shoes we usually kept for good wear, if we owned a pair, and fly down the slide. David would always be the one who had a different angle, going down backwards or on one foot. He'd set the target for all of us to try and attain.'

Like the other boys, David would whizz along the road on roller skates and hang on to the back of the electric van delivering bread to the neighbourhood, but he was the one who loved the thrill of once almost being crushed when the driver realised he was there and furiously jammed on the brakes. And later there was the famous occasion when he cycled down neighbouring Wilfield Road, knowing that the local boys would hardly appreciate the Union Jack he had attached to the back of his bicycle. He returned laughing despite having been pelted with stones on his return.

David's stunts were not always successful, however. Once he donned a witch's hat, adorned with runes, half-moons and silver crescents, stood on the roof of a shed in a neighbour's garden, and attempted to persuade the other children that if he said a few magic words he would be able to fly on a broomstick. Unconvinced, the children demanded proof. David had no alternative but to jump and had to be taken home in a wheelbarrow with a badly twisted ankle.

Their parents were no more impressed when David sometimes set their hedges on fire.

'His mother was very disappointed any time he was in trouble,' says Michael Moran. 'If a neighbour did come knocking on the door and complaining about his behaviour she would get annoyed. But normally she wouldn't say boo to a goose. I never once heard her raise her voice. She was a delightful woman, a very sweet person. I think everybody in the neighbourhood loved

her.'

Michael enjoyed playing at David's house. It was different - it was the only house in the cul-de-sac without a television but there were lots of games to play, a marvellous selection of books, and the gentle and funny Mrs Norris.

David adored his mother. Miss FitzPatrick says that while both her nephews were good, if she took them for a walk it would be David who picked flowers to take home to his mother.

'He was devoted to her,' she says. 'Once he was on his way to school and a maid who worked for Aida ran after him to say his mother wasn't too well. He just dropped all his books and came straight back to look after her.'

At the age of four David had started at Mrs Newman's school, a private establishment for the local middle-class children. It was in a large house with an acre of grounds where, like any other child, he happily played, sang and mixed powder paint for pictures to take home proudly to his mother.

He would walk to school with John past the houses in Sandymount, hearing snatches of *Housewives' Choice* on the radio as front doors opened and parents left for work.

On Sundays, Aida, John and David would go to church, St Mary's in Donnybrook. Aida loved the smell of lime blossom, so on the way they would take a long, lingering walk up leafy Simmonscourt Road. Going to church was a positive pleasure for Aida, and one which David soon shared. Once a week he went to a Bible class where attendance was rewarded with a stamp, illustrating a biblical tale, to arrange carefully in an album. He loved the class and needed no persuasion to go, but collected the stamps anyway.

Giving up sweets for Lent was a little less attractive. David was a gourmand by nature - his cousin Susan remembers how the whole family panicked one Christmas when he was six and his absence was

suddenly noticed. After a mass search he was found under a table, contentedly polishing off a large tin of pink and white marshmallows.

During Lent, his pocket money, initially sixpence and then a shilling, would be put into a little denial box, but one year he opened it up with a knife and took out the money. It was his first lesson in guilt and fear; there was little pleasure eating the sweets he had bought with his takings, for he could smell the brimstone as he swallowed them.

At the age of seven, David started at St Andrew's school in Clyde Road, about three-quarters of a mile from his house. It was mainly a boarding school, but he and John were day boys, returning home every afternoon wearing their smart, dark-blue striped blazers, ties and caps.

David's first report was an early sign of the academic brilliance he was later to achieve, especially in English; top of the class overall and first in dictation, spelling and grammar. However, he received a poor 40 per cent in maths; despite both his parents' mathematical capabilities, their youngest son was forever to be comparatively numerate. His form mistress at that time was Miss Phyllis Sleator, a gentle but firm woman and a naturally gifted teacher.

David had been at St Andrew's barely two years when he received the first major blow of his life. He was no longer to be a day boy but a boarder. He arrived at school one morning with a trunk full of carefully labelled clothes and the knowledge that he would not be going home that afternoon. Feeling abandoned, alone and angry, he sat down on his bed in the dormitory he was to share with nine strange boys.

CHAPTER THREE

Schooldays

David's plight could have been worse. Solicitors in London who still handled the affairs of John Norris favoured following family tradition, and had therefore proposed that John's two sons be educated at Christ's Hospital, a public school in London.

Fortunately, Aida decided that Christ's Hospital was too far away and settled instead on St Andrew's. There, she felt, the boys would accustom themselves to self-reliance, in an academic, sporty and disciplined environment.

John, who quickly made his own friends, initially settled in well at school. But David hated it. Gone was the sense of security and love he had enjoyed at home; and he found he had little in common with the other boarders, who were mainly farmers' sons. He felt isolated, lonely and miserable.

Worst of all was the bullying, which appears to be endemic in boys' boarding schools. Eventually, propelled by his sense of justice, David tried to inform the headmaster of its existence. It was a futile exercise; the headmaster was not convinced and David realised that there could be no remedy if there was no official recognition of the problem in the school.

On the day his bicycle was purposely and efficiently dismantled, David gathered up all the parts, knocked on the headmaster's door and dropped them on his desk, covering his papers with oil.

'Now do you believe there's bullying?' he demanded.

It was an act that owed more to distress, desperation and frustration than to courage; at other times he sat outside the headmaster's study, waiting to be caned, in a terror he can still remember to this day.

While John was exceptionally gifted in sports, particularly rugby and cricket as a fast bowler, David mostly endured rather than enjoyed such enforced activities. The only exception was boxing; he refused to participate for he found it unnecessarily violent.

The army sergeant who instructed the boys had no patience with such pacifism, and commanded the nine-year-old boy standing before him in his gym shorts to punch his opponent. David declined. His opponent was then instructed to punch David, in order to provoke him into action.

'If you do, you'll be sorry,' warned David. Both the young conscientious objector and the army sergeant were right. A punch on the nose did bring out his martial instincts, but those instincts did not manifest themselves according to the Marquis of Queensberry's rules, for David kicked out and broke the other boy's ankle.

Delighted to be banned thereafter from the hated sport, he was instead incarcerated alone when the other boys boxed, but at least was allowed to draw and paint.

On one such afternoon, wallowing in his misery, he painted a rabbit, which T S Eliot would have called the objective correlative of his condition. Rabbits had already been identified in David's consciousness as rather sad creatures that committed suicide in lavatories, and now this particular rabbit languished in a cage, his ears drooping, his sad eyes looking out dolefully from behind thick bars. The picture expressed precisely what he felt about school - and won him a prestigious prize from the

Royal Drawing Society in London.

David was a sensitive, kind and compassionate boy, so it was natural for him to befriend another pupil who was being badly bullied after it became known that he wet the bed. Any comfort he provided was temporary; the boy was hit and killed by a car as he tried to run away from school. It was David's first real contact with death, and particularly horrifying as he had identified with the boy; they were both outsiders who felt they did not belong.

David knew there was little point in escaping himself; his mother had taken a teaching job at a St Trinian's-type boarding school for girls, so the house was empty. Nevertheless, he did once run home. His mother was located, and David was promptly returned to school. At least he was not, for once, corporally punished.

He did, however, continue greatly to miss home and his mother. He even missed having to accompany her to cricket matches - though it was a sport he loathed and she loved. He would often picture her standing, ironing, in the comforting yellowy warmth of the dining room, the curtains drawn and a fire blazing, listening to the radio - dance music with Victor Sylvester, *The Silver Lining*, a devotional programme with Stuart Hibbert, or *Mrs Dale's Diary* .

He would imagine her in the kitchen, busy preparing a meal - perhaps poached salmon followed by charlotte russe. He saw her dressed in the old clothes she wore for gardening, picking some of the hundreds of daffodils she had planted under the trees, tending the salad-vegetable patch, clearing out weeds. He remembered how he used to enjoy annoying her by addressing her as 'ma' instead of 'mother', and how much fun she was. She would do things like dropping a pot on the terrazzo kitchen floor when Granny Wiz was visiting, to make her think she had broken the expensive china she had given her and on one memorable occasion, Aida had attached a piece of string to the legs of the Christmas turkey, then pulled it

from behind the door to make the legs reach out and clasp Granny Wiz's hair.

He imagined her going to hockey matches, or to a lecture on wildlife by Sir Peter Scott at the RDS. He could picture her with her friends, taking tea in Bewley's in Grafton Street or Ferguson's in Rathmines, with its lovely meringues.

David missed Michael Moran and the games they played together on wet days - games such as bagatelle, pick-up sticks, and Happy Families. He imagined being allowed to go into the 'long room' above the garage, where he had once discovered a collection of pre-World War I toys that had belonged to his mother - a magic lantern, an eighteenth-century dolls' house, a beautifully illustrated book called *The Goblin Gobblers* - as well as papers, bits of machinery from inventions, and chest-expanders that had belonged to his father.

When term ended, David did not need to use his imagination any more.

Sometimes Aida, John and David spent the summer holiday at Inch, County Wexford, where they stayed as paying guests of the rector, Canon Lloyd, an ardent Irish speaker, his Danish wife and their two daughters. Days were passed at the nearby beach; then, after supper, the two families would play a type of cricket match in the field behind the rectory, the evening air thick with mayfly, midges and gnats. When David was in bed he could hear the older children and adults still playing, and birds returning home to the rookery; it was a soothing way to go to sleep after so many lonely nights in a dormitory.

One holiday was spent at a guesthouse in Greystones, a small, pretty village south of Dublin on the coast, where David would later buy a house. The mind is a wonderful mystery: one memory of the holiday is the aromatic smell of crushed leaves from the beautiful verbena tree that stood behind the front door of the guesthouse. The other

is the day he was unable to swim in the sea, the reason floating ungraciously in the waves: elephants from a visiting circus had been bathing and left adequate proof of their incontinence.

During a later summer holiday, David was packed off to the Varsities and Public Schools Camp in Rathdrum. Presided over by a former British army chaplain, the camp had a religious flavour, although sometimes Christian feelings were conspicuously absent among the boys: a favourite pastime was catching daddy-long-legs and pulling off their wings. But in the main David's holiday at the camp was a happy time, marred only by a regular rendition of 'Abide With Me', which would inevitably trigger off a flood of tears as he recalled his beloved Granny Wiz.

It was here in the camp that David first learned about sex. Listening with the other boys to the army chaplain, he was at first incredulous, then quite revolted; and then, like many children, tried to imagine adults he knew having sex. Without two parents as an example, the Queen of England and Prince Philip popped into his mind. The resulting image very nearly destroyed his faith in the monarchy.

The return home after the end of the holidays was always made with a heavy heart, for ahead lay a new term in St Andrew's.

If David found little enjoyment in non-academic pursuits, there was no comfort to be found in lessons. As was the case throughout the Irish educational system at the time, studying and learning were done entirely by rote. To a boy with an eagerness to learn, who would dismantle clockwork cars to discover for himself how they worked, it was uninspiring and dissatisfying. When he later read *Dubliners*, the first book by James Joyce that he ever came across, David identified immediately with the description in 'An Encounter' of the teacher, Father Butler, waiting to hear the recitation of four pages of Roman history.

David was frustrated by the inadequacy of the teaching and hurt by the unfairness of some of the teachers. One geography class typified his experience. Pupils were punished, corporally, if they failed to draw a map on tracing paper, even though tracing paper was not provided by the school. Using what could be described as either initiative or miltancy, David produced the required map, sketched on Bronco, the school's transparent lavatory paper. His act may have been received with much amusement by his classmates but he was of course belted for his efforts.

Later, with an adult's perspective, David realised that the school did go through a particularly unsettled period when he and John were pupils there, and that there were in fact some nice children and good teachers in St Andrew's.

He made no lasting friends there, but remembers with affection a very kindly man called Mr Banks who once caught David and some other boys frying snowballs on a stove and who smacked their freezing cold hands. The boys all burst into tears, but David remembers Mr Banks being more upset than any of them.

Then there was Rashers Ryan, the painting teacher, who was thought to be rather bohemian as he wore a corduroy jacket and dark blue jacket and tie. There was also a man the boys called 'The Sergeant', who used to be in the British army and who would ring the bell for change of class. He appointed 'agents' - spies, in other words - to tell him about any bad behaviour amongst the pupils. It was rather noxious, but David admits with embarrassment that he ached to be an agent, but never qualified.

If the young David Norris received little education at St Andrew's, during the time he spent there he did at least discover a useful trait in his personality. 'I might have been a great artist but I was cursed with a happy nature,' he says with amusement today. 'If happiness isn't intrinsic in a situation, I set about manufacturing it as

quickly as I can. Had I been one of those blighted personalities, who knows? I might have written *A Portrait of the Artist as a Boarder at St Andrew's*. But I never got round to it.'

And there was no need. His mother had stopped teaching and decided that her youngest son could change schools and live at home. So at the age of eleven, David started at the High School in Harcourt Street.

Here he blossomed. The teachers at the High School not only loved their subjects and knew how to engage their pupils' interest and imagination, they also encouraged them to look beyond stark facts to find the truth beyond. David was fascinated. Finally, history became so much more than a mere series of dates and names. Instead, David analysed the human personality, political development, the impact of historical figures. Geography was no longer simply a study of the shape and location of a country. Instead, in his geography classes he learned about the geology, economics and culture of other countries.

David was enthralled to hear for the first time, from the Irish teacher Frank Peters, stories like those of Peig Sayers, about a facet of Irish life he had never come across - that of rural Irish life; he had great fun watching his science master singe his eyebrows when experiments went wrong; but it was English that really filled him with joy.

Much credit for this was due to his teacher, Jack Cornish, who, with his little bald head, resembled a Roman emperor, or a tortoise peeping out of his shell. But Mr Cornish was never a figure of fun who struggled to keep discipline; there was no need for him even to raise his voice, much less resort to physical violence, such was the pleasure of attending his class.

Nearly forty years later, David can still remember reading, on Mr Cornish's recommendation, 'A Dissertation Upon Roast Pig' from Charles Lamb's *Essays of Elia*, and how he had admired its humour, humanity,

economy of line and beauty of language.

Maths still proved difficult, but David was soon at the top of his class and winning prizes for English. Moreover, he also found social as well as academic success, for he now for the first time had real school friends, two in particular - John Dick and David Miller. However, David Miller was unwittingly to cause him deep anxiety and despair for later David fell in love with him.

Discovering he was homosexual, then coming to terms with the implications of that discovery, was a very gradual and extremely painful process, making the awkward path of puberty even more disturbing than usual.

David was about nine when he realised he was drawn to males. The feeling was at first an emotional sentiment, which would not have caused him any bewilderment, for he was surrounded by boys at school and stimulated by his teachers. But when those emotions became sexualised, when men became an erotic interest and his friends began to pay what he felt was a rather unhealthy attention to girls, it slowly dawned on him that he was different. At a time when he had no word to make sense of this self-discovery, when, even if he had, homosexuality was a taboo topic, it was an unpleasant experience.

'I used to go to bed at night, crying, praying that it was all a mistake and that I'd wind up different in the morning,' he says. 'I suppose I coped with it by developing a kind of fantasy life, living through books; and by keeping myself busy, organising and doing.'

David had already displayed a need to distinguish himself amongst the children of the neighbourhood; now, 'keeping himself busy', he began to demonstrate an organisational ability, which bordered on dictatorship. One occasion on which this was demonstrated was the staging of a play he had written which was to be performed in Michael Moran's garage; any charge of

'Play by Toad, Recitation by Toad, Speech by Toad' would have been accurate. David had cunningly organised the production so that he was writer, actor, manager and star; he was furious when his brother and friends used their seniority to appropriate the proceedings and demoted him to second assistant stage manager. That audience in Michael Moran's garage sat on a little row of deckchairs; later David would perform in front of larger and larger numbers.

It was also at this time that his verbal proficiency and persuasiveness as a speaker began to emerge. As a member of the debating society, David represented his school in competitions and was once terribly disappointed only to be awarded second place. A few days later he was summoned by his headmaster. Senator Owen Sheehy Skeffington had been present at the debate, and had written to say that in his opinion David Norris had been unquestionably the best performer there. This letter meant far more to David than winning first prize. That a man who deserved immense respect (and whose father had been one of James Joyce's closest friends) had thought so highly of him remains more than a proud and treasured memory for David Norris. Chairing a debate at UCC some ten years ago, he was similarly struck by a student who received no recognition after making a brilliantly witty and original speech. Remembering his own disappointment, then the subsequent consolation and encouragement Sheehy Skeffington's letter had given, David took the trouble to write to the young man.

Although he was comfortable with the spoken word, performing musically made David extremely nervous. Despite Aida's horror of being in debt, she had bought him an upright piano on hire purchase for £130, an enormous sum in the early 1950s, and when he had reached the age of ten, had enrolled him at the Reade Pianoforte School in Harcourt Street, above a shop selling artists' materials. David went there once a week; he would push open the heavy hall door, climb some stairs,

and already smelling the wax polish that battled daily with the dust on the wooden floors inside, would step into an aura of old-fashioned Parisian theatricality.

Miss Reade, an elderly woman swathed in furs, her Alastair Sim-in-drag impression set off by a toque and *pince-nez*, taught in the front room. David received his instruction across the floor and behind some folding doors, in a room that contained a grand piano for advanced students, an upright where he began, a tripod on which was a bust of Dante, and his teacher, Lily Huban.

Lily Huban was an exceedingly thin creature with birdlike features, invariably dressed in a fur coat and little boots; ethereal, almost disembodied, the piano teacher could have stepped out of a Ronald Searle drawing. Although Irish, Lily Huban was very much a citizen of Europe, in particular Paris, for she had studied at the Conservatoire in the 1920s and been Alfred Cortot's demonstration pupil. Occasionally she would refer to her teacher; if David was playing the Nocturnes and struggling with a suspended high note, she might murmur: 'Cortot would say "*une etoile*".'

Her young pupil knew little about the great master except that his seemed a name to conjure with. Nevertheless he understood and appreciated Lily's background, and was in awe of her air of spirituality and refinement. So it was to his horror that one day, when Lily was attempting to relax his wrists, he discovered that yet again his school diet had resulted in a certain degree of flatulence. The little boy, hot with embarrassment and effort, persevered as long as he was able, tensing his muscles to prevent what seemed an inevitable, humiliating outbreak. Finally, struck by cramp in his thigh due to the conflicting signals received by his muscles, his leg shot out and he was forced to watch in dismay as the piano, on rollers, sailed across the room and crashed into the double doors.

It was a rare unhappy experience at the Reade

Pianoforte School, for David delighted in his lessons, which continued until he was twenty. Under Lily Huban's influence he came to love the haunting melodies of Chopin, which he would play with expression and understanding. Having inherited his mother's musical ability - Aida played the piano and sang in the Culwick choral society - he became an excellent pianist, gifted enough to consider it as a career. However, he was prevented by timidity in playing and performing, and lacked the commitment to practise regularly.

'We would be outside playing and his mother used to knock on the window and tell him he should be practising,' remembers Michael Moran. 'He never studied that much either. Our next-door neighbour, Mr Sugrue, was a school inspector who would come out and chat to us occasionally, and remind us it was important to work hard. When he'd gone David would tell us there was no need for him to study because he had a photographic memory; all he had to do was flick through a book before an exam. We believed him. We thought he had a magic power.'

There was no doubt among his peers that an academic career of some kind awaited David. By his teenage years he had become a voracious reader. Michael remembers Sunday outings in the car with their friend, John Doherty, and his parents, when Mrs Doherty would ask the boys whether they had read certain books.

'John and I hadn't read any of them, but David always had.'

David had developed a love of literature. Losing himself in books helped him to forget he was 'different'. Meanwhile, he had a living example of a man who was immersed in his own fantasies.

Unconventional, lively and original, Uncle Dick was a strong influence on the teenage boy. Well read, well travelled, well spoken, Uncle Dick was an incredibly glamorous figure in his nephew's eyes. Always immaculately dressed, he wore a large oval ring (now

worn by David) on his little finger, smoked Turkish cigarettes, and, almost an indictable offence at the time, used aftershave.

After retiring from his post as chaplain to the Queen in 1957, Uncle Dick had been glad to leave the upper-class social circles of London for the little parish of Ashwell in Rutlandshire, where he avoided the local gentry, preferring the more earthy conversation of the butcher, also an army man, and his correspondence with Brendan Behan. Nevertheless, Colonel the Reverend Richard William FitzPatrick was quite capable of returning a letter to the postman if his surname had been spelt without a capital 'P'.

Cultured yet sometimes coarse; devout, yet irreverent - he referred to his parishioners not as his flock but as his herd; proper yet often rascally and with a wonderful sense of humour, Uncle Dick was *fun*.

John and David would receive postcards from around the world from Albert and Lizzie McGucky, two children their age who recounted their adventures. They were not friends, they were not real, but simply invented by Uncle Dick for his nephews', and presumably his own, amusement.

When making a visit to Dublin, Uncle Dick would take John and David on expeditions across the city, but his favourite outing was to the Abbey Theatre.

Whether it was a calculated fantasy, or whether he actually believed it, Dick appeared convinced that the driver of the single-decker number 52 bus which took them to the theatre bore an uncanny resemblance to the leader of the Abbey orchestra, Sean O Riada, and therefore had to be one and the same man. He would sit at the front of the bus, an elegant, bejewelled figure in a haze of cigarette smoke, and tell the accommodating driver with a tap of his walking stick: 'You'll want to hurry up old chap, the orchestra will be starting in about five minutes.'

After the performance he would similarly address Mr

O Riada: 'I hope the bus will be on time.'

It was outrageous but harmless behaviour, the sort that his nephew indulges in today, but Uncle Dick's greatest gift at the time was in allowing David the vision of respectable non-conformism.

David was busy and lost in books, but despite his prayers, his sexuality had not been conventionalised. Instead he would wake in the morning having dreamed of turning into a girl and marrying a handsome, dashing man. His 'difference', which he came to understand was homosexuality, would not go away. More shocking was the realisation of its consequences. Loving men was unacceptable: it disgusted Church and society, it even broke the laws of the country. To practise this love could result in prosecution, even in prison. Even to have it known would leave him subjected to scorn, abuse and hate. David understood that his sexuality had at all costs to be kept secret.

However, at the age of fifteen, tormented by his deepening love for David Miller, David could stand his secret sentiments no longer and one day confessed to his friend that he was in love with him. The response was kind yet disappointing. David Miller accepted the admission without the slightest discomfort or horror, but clearly did not share David's passion.

The friendship continued to flourish (and continues - David is now godfather to one of David Miller's children) but so too did the feelings of fear and isolation. By the time David was ready to leave school he saw a desolate future for himself.

'It was almost as if I wasn't a real person at all, because the realisation of your personality depends on success-fully incorporating all the different strands and elements within. But here was a major area of my life about which I had to keep completely silent. And I had to project something in its place so as not to be found out. A career, a profession, political involvement ... these things were the real world, which was composed of heterosexuals.

My reality was insubstantial, unrealised, unrealisable. It was terrifying.'

With little idea of what he would, or could, become, David simply drifted - into university.

Trinity Scholar

For a boy who had been rather tenderly brought up, David's first summer job, before going to Trinity, was a rough shock. The necessity of earning some money, and the temptation of being near David Miller, who was still the object of acute puppy love and who had found a job in England, conjured up for the ever-hopeful David a vision of a simply lovely romantic liaison abroad. So he hopped on a boat at Dun Laoghaire in pursuit. Ecstatically happy, he sat in the train taking him to the north of England, listening to his transistor radio in anticipation of his first foreign adventure. He hadn't stopped to consider that the job was in a pea-canning factory - a pea-canning factory in Cleethorpes, a popular British seaside resort in South Humberside, which would hardly be to the liking of a middle-class boy.

His spirits descended rapidly on arrival at this 'ghastly place'. They slumped yet further when he saw his accommodation, a dirty, damp hostel with a musty smell of decay and mushrooms growing out of the peeling wallpaper. In the room he was to share with David Miller and more than a dozen others, the beds, with their well-worn mattresses, were jammed together - clearly every

advantage was being taken of the visiting Irish workers. With distaste David gingerly climbed over the beds to reach his own, where he deposited his suitcase, which at his mother's insistence contained an unnecessary amount of clean, ironed and folded clothes.

Unfortunately the reunion with David Miller failed to revive David's former optimism. Nor did the factory work alleviate his woes. The pea people were singularly unimpressed by his efforts and sacked him after three days.

David soon found another job, helping a man called Old Fred to knock down still-existing bomb shelters with a sledge hammer. However, the thrill of receiving his first-ever wage packet was insufficient to keep him in Cleethorpes. Denied the company of David Miller, since the hostel was owned by the pea-canning factory and admitted only its employees, and deciding he was not as yet quite qualified to be a member of the working class, David returned to Dublin. His adventure had lasted three weeks.

At the end of the summer he started at Trinity College with little sense of purpose or excitement, and also without the expected scholarship. Due to an oversight David had been taught the wrong course for the scholarship examination. He nevertheless managed to walk off with the Walter Wormser Harris prize, awarded to the student who came first after the scholarship winners, and was pleased enough to have spent some enjoyable months studying Horace's *Odes*.

For the first two years, David's course in English was very personal to him. Literature became a tool in a sometimes painful, sometimes reassuring process of enquiry into his own identity, sexuality and relationships. This discovery resulted in passionate and original essays, without the usual recourse to the critics or respect for their wise words.

Even today, David regards many critics with aversion,

his feelings ranging from mild cynicism to angry contempt.

'One of the problems with criticism nowadays is that it is frequently merely opinion and full of second- and third-rate minds who write badly and have absolutely nothing to contribute except obfuscation. They belong to a type of Druid circle, using a kind of magic, a specialised language with long words, in order to frighten the ordinary public away. I hate them and everything they stand for.'

He blames the French: that is, theorists such as Lacan and Derrida, who certainly may not have overwhelmed too many students with their accessibility.

In contrast, writers such John Dover Wilson won David's admiration. D H Lawrence, too, was admired for the 'violent bias' in his studies in classical American literature.

'He was a wonderful critic, wrong a lot of the time, but wrong in the most marvellously illuminating way. And instead of the dry, picky distaste you find with some critics, he wrote with passionate commitment - he had a love and celebration of literature.'

Reading critics he both liked and disliked informed David's own opinions; he responded similarly to lecturers.

One was Jeffrey Thurley, 'a curious, diminutive, wizened creature', whose special area was romantic poetry and who illustrated to David that one can learn from disagreement.

'I hated every word he said, and every word he said was a provocation. As a result, I learned a great deal because he was a very clever man, and in order to defend my ideas and principles, which he outraged consistently in his lectures and tutorials, I was forced to dig deep into my own resources and provide answers and arguments.'

David was also taught by Robert Butler Digby French (RBD), a small, balding man with a prominent nose on which balanced transparent-framed glasses. Charming

and old fashioned, he was a scholar of eighteenth-century literature and the medieval mystery plays, but his passion was P G Wodehouse. When David proposed presenting a piece on Joyce, whose works were not included on the syllabus, RBD removed the pipe from his mouth. 'Not quite my thing, dear boy.'

Still, he allowed the enthusiastic student to produce his piece.

'We had a great old discussion but it really wasn't his thing,' remembers David fondly. 'For Joyce to mention the human bowels went utterly beyond the pale as far as RBD was concerned. And as for sex! There may be romance and engagements in P G Wodehouse, but no sex; after all, who could have sex with Madeleine Bassett or Gussie Fink-Nottle?'

David's interest in Joyce had been awakened some years before when he had pinched two cigars and a copy of *Dubliners* from Uncle Dick. Both had been a disappointment. The cigars made him cough and the short stories had no conclusive ending, fizzling out in a rather unsatisfactory way.

However, intrigued by Joyce's method of writing and excited by an instant recognition of the Dublin landscape and its social detail, David persevered and read other works by Joyce. Further inspired and increasingly delighted, he prepared a paper on *Finnegan's Wake* from which he read extracts to a university audience that included Anthony Burgess, a visiting guest speaker. It was, wrote Burgess in David's copy of the book, 'an ear-and mind-opening experience' to hear him read from *Finnegan's Wake* in a Dublin accent. Later David would combine his love and knowledge of Joyce with his dramatic ability to perform highly acclaimed one-man shows. For now he contented himself with the gold medal the college had awarded him for his paper.

Another lecturer remembered with affection and admiration is the poet, Brendan Kennelly, 'a fine teacher, open to ideas, great fun, rather subversive and, rare

among academics, with a generosity of spirit and utter lack of jealousy'.

Unlike many of his contemporaries, David's sexual education continued to come from books rather than actual experience. His social life was limited; still convinced he was an oddity, he was entirely unaware there were other gay students. He would see his friend Michael Moran; David Miller, who was at Trinity studying medicine, still fulfilled David's need for emotional excitement, albeit one-sided. But he had no interest in accompanying his friends to dances. What was the point of dancing with women?

He did, however, enjoy literary readings and meetings, where he met and became friendly with another undergraduate, Mary Bourke, later to become President Robinson, who was studying law but greatly interested in English literature. When she asked him to show her a side of Dublin with which he was familiar but which she had never experienced, he was only too happy to oblige; accordingly, the two of them set off one evening on a literary pub crawl. It ended late, with David seeing his friend home to Westland Row.

'To say the least of it I was a bit of an innocent. I didn't know of his sexual orientation at that time,' remembers of Mary Robinson, now President of Ireland.

They were good but not close friends; how could David have shared his terrible secret? Like many homosexuals, even today, the fear of losing friends, the uncertainty of how they might react to his real identity, forced him to remain silent. Conversations were clouded by imposed concealment and relationships were damaged, for they were shrouded in deceit.

It was all painful, especially for a naturally open person like David. And it was a strain, this double life in which every gesture, every word, had to be checked, this life in which every nasty jibe and joke about homosexuality had to be borne with submissiveness, even though they attacked his very essence. It suppressed

his sense of self, sapped at his self-confidence, stripped away any hopes of future happiness. How could he be whole in a society that despised him, degraded him, denied him the right to live and love like others?

There was little comfort to be found in his religion, for he could criticise the Judeo-Christian ethic as the source of much hatred of gay people. But, paradoxically, David sensed a closeness to the historical figure of Christ, who had also felt so totally alone.

It was confusing and depressing.

Desperately lonely and in need of unreserved and unconditional love, David tried to reach out to his mother by dropping a few hints about his sexuality; she was perhaps too vague or innocent to understand. He did not press further. He wanted to ease her cares, not add to them.

His older brother John, who, unlike David, had stayed on at St Andrew's, but then had become similarly disillusioned, had not found a suitable career, nor even settled into a job, and was a worry to his mother. By this time, Aida's health was deteriorating; she had heart trouble and this was a source of great anxiety to David.

With his own emotional turmoil and concern for his family, his days as an undergraduate were hardly carefree.

In 1965, after two years at Trinity, David took the examination for a Foundation Scholarship. This prestigious distinction and proof of academic excellence was awarded to students who achieved the highest first-class result, and who were then elected by the university to become Scholars.

David chose to be examined in pure English, something no student had ever previously attempted; the practice was generally to combine English with another Arts subject.

Aida was in hospital, recovering from a heart attack, when David told her about the system of the Trinity

Scholar.

She sighed. 'It's a wonderful honour,' she said.

'Well, you're talking to one,' he replied.

It was a proud moment.

'She was so thrilled. I think it cured her, and as far as I was concerned, that was the best part of being a Scholar.'

David had joined an elite that now included his friend Mary Robinson, also newly elected, but had he felt any conceit the university dinner for Scholars was suitably humbling. Seated next to Professor Pyle, a distinguished expert on Milton, the undergraduate attempted conversation by remarking that the soup was rather cold.

'Yes. It is iced cucumber,' responded Professor Pyle drily.

The Provost's party was more fun, but this time demonstrated David's innocence. Deciding to dress up extravagantly for the occasion, he had taken himself off to Duke Street where he had bought a pink shirt and matching tie and silk handkerchief, quite unaware that such an outfit might be taken as a statement of his sexuality.

When one of the other winners congratulated him on his bravery and admired his prettiness in pink, David did not even realise that he was being flattered by a gay man.

'He thought I was waving a flag to say I was a fairy, but I hadn't a clue what he was talking about. The pink had just appealed to me. It must have been innate.'

As a Foundation Scholar, David's university fees were now paid; in addition, he received £350 and the use of free rooms at college. He decided to take advantage of the accommodation and moved into number 17, 11 Botany Bay, an eighteenth-century residence that appeared to have received little updating since its construction. The building had no entrance door and was therefore a noisy, chilly place to live and work. It had few home comforts - a broken gas fire, a scrap of torn carpet, basic furniture and only cold running water.

Nevertheless, David enjoyed living there, largely

because he found himself sharing with the captain of the GAA. Soon he had a new set of interesting acquaintances, a fuller social life, and the experience of watching football matches at Croke Park thanks to Tony Hanahoe, captain of the Dublin football team, together with the accompanying nationalist celebrations of marching bands. For a boy from his Protestant, middle-class background it was a revelation, and an insight into the loyalty that lay at the base of a political party such as Fianna Fáil.

After several months in rooms, however, David returned home to Sandymount, suffering from pneumonia.

He woke one morning, went downstairs and saw the post still lying by the front door. Usually his mother picked it up. The house was strangely quiet. He ran upstairs, opened the door to her room and found her dead in bed. Aida had suffered a sudden heart attack in the night.

After the initial shock came the unpleasant task of helping the doctor straighten out the body, for rigor mortis had already begun to set in. Any notions, ingested from books, that death was a romantic experience, where one declined slowly and gracefully on a sofa with blue silk hangings and flowers, were abruptly destroyed.

At the age of twenty-one, David no longer had any preconceptions. He had been forced to challenge them all since childhood.

The death of his father had made his family different and had shaken the material security he might have taken for granted. At school he had learned about the Famine and the Penal Laws against Roman Catholics. For a Protestant boy who had been brought up with the idea that the British Empire was the civilising influence *par excellence*, who had been made to stand up at the end of BBC radio broadcasts for 'God Save the Queen', it was a frightful shock. Then to discover that he was gay and therefore unwelcome in society meant confronting all his

moral, and religious, ideas. All this he had to do alone - and at a time when the collective unconscious assumption was that Ireland was a society made up of white, heterosexual males (and their non-working wives), when there were no national scandals of incest or rape or priests who were not celibate - scandals so profoundly shocking that people were forced to question their beliefs and challenge their prejudices; a time when those who disagreed with the majority stayed silent.

David Norris emerged from his traumas with strong, definite convictions, based on raw, personal experience. If colleagues were later to find him intransigent at times, and the public to find him outrageously outspoken, they were not to know the struggle that formed his beliefs.

David was enchanted. He was reading *The Great Gatsby* and there were descriptions that conveyed exactly - but *exactly* - his own concerns. Fond of jazz, he had been listening to old records from the 1920s; he had heard that 'stiff, tinny drip of the banjos'.

He was an outsider, a mere witness to relationships, for they seemed to belong exclusively to heterosexuals; he had suffered from unrequited love. Now he was being electrified by the sensitive description of Gatsby's visit to Daisy's home. He understood Gatsby's despair, empathised with his lost love. It was as if his own feelings were being recorded, and exquisitely so.

The book was included in a course David was taking in American literature, and in his final examinations in the subject he wrote brilliant, inspired and passionate essays. He received astronomical marks, an invitation to give a series of lectures, and the offer of joining the teaching staff in the English department of Trinity College. He had gone from undergraduate to graduate to lecturer, all within the space of three days.

It was, nevertheless, a wretched time.

After their mother's death, John and David had sold the family house in Sandymount, and with his half of the

proceeds, David had bought a large, modern house in Dundrum.

Now, at the age of just twenty-two, he was a property-owner, a lecturer, a loser in love (David Miller had just married and moved abroad), and desperately missing his mother. While John had seemed to turn into himself and perhaps failed to grieve properly - to this day he speaks little about his family and has never been able to visit his mother's grave - David had the added emotional isolation of his secret sexuality.

His social life consisted of going into town for a drink with Michael Moran - to the Bailey, the Old Stand or Davy Byrne's - where they would meet up with a crowd of friends. Fortunately they all seemed more interested in laughter, politics and drinking than in women, so no one discovered his awful secret.

And certainly no one would have guessed that he was grieving, lonely, frightened and unfulfilled. Outwardly David was absurdly happy, outrageously funny, and never failed in his role as the group's entertainer.

'He was always the leading light among us,' says Michael Moran, 'and a marvellous mimic. But it got him into lots of trouble. I remember one day we were walking over O'Connell Bridge and David started to mimic a man in front of us who was limping. It was very funny until the man, limp or no limp, turned round and chased him all the way back to the GPO.'

David obviously enjoyed his status as the resident clown. However, despite his own insecurity and secret distress, he seemed to care little if others enjoyed rather less being the butt of his humour.

'He wasn't malicious,' says Michael Moran, who knows him longer than most people, 'but he mimicked people without care. If someone around was sensitive, that was just too bad. And sometimes he would go for the jugular if he didn't like somebody. He could make people feel really small, because verbally he could outwit anyone.'

It took no time at all before David Norris became well known outside this circle of friends for his ability to entertain. Even students who were not taking his courses started to attend his lectures, for they belonged more to the stage than the classroom.

Initially, however, he had been very nervous, terrified even, to be faced with a class of people 'who were bigger than me, with moustaches and hairy chests, who probably knew a great deal more about life than I did.' In addition he had been dismayed to find that his first lectures would be on poetry, for which he had little passion; he had been alienated by the number of amateur poets in Dublin and the academic snobbishness that derided his favourites such as Dylan Thomas and Padraig Colum. David decided that instead of studying prescribed texts in his lectures, he would conduct an enquiry into the very essence of poetry. His students read 'the grasshopper poem' by e e cummings, poems with no sounds at all, poems with seemingly no sense, poems they had perhaps not read since childhood.

As soon as he started to speak he found his confidence growing; once he was allowed to teach a syllabus that extended beyond poetry and he became lost in his love of literature, he soon forgot that his students seemed much more mature than their teacher.

After four years as a lecturer at Trinity, David decided to move out of Dublin to Greystones, and bought a large Edwardian house on a smart estate, the Burnaby. For a while his brother, John, came to live with him. Despite a brilliant mind, John had decided against furthering his education, but had finally found a career that suited his taste for travel and personality perfectly. He had become a lorry driver. Despite such differing careers, they got on well enough, and John was away much of the time, travelling all over Europe. He earned good money, much more than his younger brother, and decided to invest in a new truck, a bigger truck - in fact, the biggest truck in the

country. It may have looked out of place on the estate, but on the day it was delivered John was so pleased he decided to open the bottle of champagne he had been keeping for months in the fridge, awaiting a suitable occasion.

'I discovered the little bastard was after drinking it,' he recalls with amusement.

John and David would often go out drinking together when John was home, but they never discussed their private lives. 'He didn't talk about his sexuality, in the same way that I wouldn't have told him I was chasing certain women,' says John.

However, he did of course tell David that he had met Mary, a straightforward young Dublin woman who was working on the Ireland-to-France ferry. Soon after that, they were engaged.

David was delighted for John and Mary despite being denied similar happiness himself. He had not experienced any of the dating that young heterosexuals take for granted. He had never fussed about his appearance before a night out, never kissed in the cinema, never nervously met her family or introduced her to his.

Even if he did meet someone special, he knew he would not have the right to show his affection in public, to hold hands in the street, to sit in a pub with an arm around his shoulders, to talk excitedly about his new love.

He lived in an empty house, and lived an empty personal life.

Gay Rights

The horrifying actions of the Nazis during World War II were not directed only against Jews; homosexuals, too, were feared, reviled, persecuted and confined in concentration camps where they were forced to wear a pink triangle on their clothes. (Later the pink triangle would become a symbol of pride and resistance for the gay movement, and would also be used by AIDS activists with the slogan 'Silence equals death'.)

A deepening worldwide hostility towards homosexuality had begun in the latter half of the nineteenth century. Until this time, in Europe, sexual relations between men were usually treated as an unexceptional, acceptable manner of achieving physical pleasure.

Free of ecclesiastical execration against the corruption of the natural order, sodomy was simply considered part of general debauchery, often less sinful than blasphemy, and certainly less subject to disapproval or legal intervention than rape.

There were Biblical condemnations of sodomy, but in the medieval era the Church seemed to be more concerned about banning sexual acts that might result in extramarital conception than in proscribing sex which did not

carry this risk. And there is evidence too that in seventeenth-century England local authorities were more interested in preventing the birth of bastards who might have to be supported by the parish than in preventing other forms of sex.

It was a time when more emphasis was put on a man's sexual satisfaction than on the sex of his partner. Society was hierarchical, ruled by men, and they did not feel constrained to take only women as partners.

Ireland, too, had a history of permissiveness in relation to homosexuality: the Brehon Laws regarded it non-judgementally as one of the reasons for divorce; early and medieval Irish poetry was frequently homoerotic; and the pre-Famine era appeared to have had an open attitude towards sexuality.

However, the ways in which sexual acts are perceived and treated derive from the societies in which they occur; if they change, it is because these societies have changed. From 1770, after the arrival of the Romantic movement in Britain, marriage came to be seen less as a social convention and way of containing men's lust, and more as a source of romance and empathy with a woman. To look outside the marriage for sexual fulfilment, which many men who had enjoyed relations with other men had previously done, now became offensive.

By the end of the eighteenth century, men who directed their sexual desire at other men had been stereotyped as effeminate and accused of deserting their sex. While gentlemen in the late seventeenth century had embraced or kissed one another freely, public displays of affection between men were now quite unacceptable. Labelled and categorised, men who wanted sexual relations with other men were forced to seek secretive relationships or anonymous, bought sex.

In the nineteenth century, homosexual men began to find that their desires carried a disturbing reputation. Until 1869, when the word *homosexualitat* was coined, the

concept of 'homosexuality' as such had not existed - no one believed that sexual attraction between men represented those men's whole identity, so there had been no need for a name. But this was a time of instability, when people wanted strict rules and universal guidelines to govern their lives, and one moral outcome of this desire for order was the concept of sexual 'normality', as if human beings had no taste for variety, no possibility of choice.

Medical explanations for sexual anomalies were sought, and homosexuals were soon denounced by psychiatrists as sexual perverts, degenerate lunatics and moral imbeciles.

With the new attitudes towards sexual relations between men came a growing risk of prosecution; it was patriotic and cathartic in a climate of economic difficulties and social disorder. By the end of the 1890s, a new perception of the homosexual as criminal had been constructed, and prosecutions had become an international phenomenon.

In 1885, legislation criminalising all sexual intimacy between men was introduced in Britain - and applied also to Ireland. Its effect was further to increase hostility to homosexual acts.

Ten years later, this piece of legislation also allowed for the prosecution of Oscar Wilde, accused of practising the 'love that dare not speak its name in this century'. The trial provoked waves of national and international revulsion.

From the *News of the World* to the *Daily Telegraph*, British media reaction to his arrest and subsequent conviction demonstrated the depth of public disgust now felt towards sex between men.

[Wilde] is now in the hands of the police charged with one of the most heinous crimes that can be alleged against a man - a crime too revolting to be spoken of even by men. *The Star*
Society is well rid of these ghouls and their

71

hideous practices. *News of the World*

> Let us hope that his removal will serve to clear the poisoned air, and make it cleaner for all healthy and unvitiated lungs. *Daily Telegraph*

Social change, legislation, fears implicit in degenerationist psychiatry, the Wilde trials - all had combined to produce a wave of hatred towards homosexuality.

Ireland was not immune to this hatred. At a time when the issue of Home Rule and the threat of the break-up of the United Kingdom loomed, the Irish nationalist press pursued 'homosexual scandals' as a means of undermining certain highly placed British officials in Dublin and discrediting their administration.

Fear and abhorrence swept, unabated, into the twentieth century. In the 1930s, in Ireland, a government committee reported that 'gross indecency between male persons' was 'spreading with malign vigour'.

The view that homosexuality was increasing and should be combated persisted after World War II, with the Americans being particularly paranoid.

'Sexual perverts ... have infiltrated our Government in recent years,' warned the Republican Party national chairman in the 1950s. Such 'perverts' were 'perhaps as dangerous as the actual Communists'.

Two centuries earlier sexual relations between men had been acceptable. Now homosexuality had been labelled and homosexuals become a dangerous minority. By 1960, faced with public revulsion, legal constraints, political fears, moral outrage, religious fury and medical explanations of sexual abnormality, homosexuals had been forced underground.

By the end of the decade, however, their voices would be heard.

On 27 June 1969, police raided the Stonewall, a gay bar in the heart of Greenwich Village in New York, never suspecting that their actions would reshape gay life

forever. They expected a routine raid - homosexuals were frequently arrested, physically and verbally abused, then freed without prosecution or resistance. But that night the gays fought back. Some barricaded themselves inside the pub, others battled the police outside.

As news of the incident spread, lesbians and gay men from all over the USA came to give their support, resulting in street riots that lasted three days and received widespread publicity.

It was out of the rallies and demonstrations that followed that the first mass movement, the Gay Liberation Front, was formed. The GLF soon advanced beyond the USA to Europe; a group was set up in London in 1970.

The GLF protested against gay oppression and developed definite political aims for its eradication, including the breakdown of existing social institutions. Together with the formulation of a political agenda came the rejection of the negative perception of homosexuality as being something of sin and sickness. In its place was an emphasis on pride and affirmation. 'Coming out', the public expression of a gay identity, became a positive, political act.

Gay activism in the USA and Britain provided an impetus, but it was also the radical economic and social changes in Ireland that allowed a gay movement to establish itself here. In the 1950s the country had been through a period of deep depression. Economic growth was non-existent, inflation high, living standards low, unemployment rife, and emigration approaching 50,000 a year, a figure not far below the birth rate.

The state's approach to economic policy had always been conservative, but at the end of the decade, under the leadership of Sean Lemass, there was unprecedented state intervention in the economy. Investment, the nurturing of exports, the opening-up of the economy to foreign investment, new public bodies concerned specifically with development - these were the

government's priorities. The results were soon visible: a huge increase in GNP, a dramatic rise in the numbers of skilled manual and white-collar workers, a fall in emigration, new factories and housing schemes, and more consumer goods.

Change was not restricted to the economy, however, as described by John A Murphy: 'After a long period of conservatism, repressiveness and censorship, there began in the 1960s a new frankness of discussion, a spirit of self-criticism, a liberalisation of religious thinking and a rejection of paternalism.'

As he also points out, possibly the single most powerful instrument of change was the introduction of a national television service. A national radio service had been in existence since the 1920s, but the advent of Telefís Eireann in 1960 had a huge impact on Irish life and traditional attitudes: reflected in the saying that there was no sex in Ireland before *The Late Late Show* . Topics such as the place of the Catholic Church, which had been virtually taboo, were for the first time openly discussed and debated.

The more relaxed climate allowed for the establishment of various progressive movements, such as the Irish Family Planning Association, founded in 1969. A year later came the founding of the Irish Women's Liberation Movement. It was particularly the women's movement, combined with these changes in Irish socio-political culture, that created the space in which a gay movement could form. And David Norris was to play a very large part in that gay movement.

Although David had slowly come to realise that he was not the only homosexual in Ireland, negative feelings towards his own sexuality and society's imposed quarantine on its practice had made it quite impossible for him to attempt meeting other gay men. All he had was the memory of his one and only experience of the secret social life of homosexuals. At the age of seventeen

his friends had thought it would be terribly sophisticated to go to Bartley Dunnes, a pub known to be rather risqué and frequented by gay men. The pub had been a revelation to the wide-eyed, innocent, middle-class boy - the exotic drinks stacked on mirrored shelves, the little statues of Michelangelo's David, the posters from Parisian, West End and New York theatres, the Chianti bottles covered in candle wax that cast a flickering light over the low tables, the velvet curtains, the nooks and crannies in which men, young and old, eyed each other up. David had a delicious feeling of being on the edges of morality. But actually going there alone was too forbidding. His entry into a gay social scene would have to come about in a less threatening, non-sexual manner. A gay activist group would be the perfect *entrée*, and now one was being set up at Trinity.

Edmund Lynch, who would later help David in his campaign to be elected to the Seanad, remembers an early meeting of the group at Trinity College in 1974.

'This man came in, flamboyant, wearing a black coat and hat. It turned out he was David Norris, a lecturer in English.'

David left the meeting energised, elated and fired with happy enthusiasm, fully committed to work for the rights of homosexuals. His new commitment would, like every idea, interest and passion in his life, be put before his own concerns and consume vast amounts of his time. And like all his enthusiasms, it had to be acted on immediately. As chairperson of this Irish Gay Rights Movement, with the able assistance of its general secretary, Sean Connolly, David set about working out a political agenda as well as finding premises which would provide social amenities.

After the short-term rental of an office in South Richmond Street, a building was found in Parnell Square which David discovered to his amusement had been the home of a Dr Stoker. Not only had Dr Stoker developed the trepanning operation, a primitive form of brain

surgery which may have influenced the work of his relative, Bram, but the family came from Maryborough and were blood relations to David's mother's family.

When Miss FitzPatrick later found out, she was as amused - the poor man would be rotating in his grave at 78 rpm at the thought of homosexuals having fun in his home, she told David.

And they were having fun. Although a few gay bars had existed in Dublin, this house was to be the home of the very first disco for homosexuals. David was amazed at its popularity, and astounded that instead of the sixpence collected in biscuit tins at meetings in Trinity, real money was being made from the numbers pouring in.

His overriding pleasure, however, came from the enjoyment the facilities were giving to gay men. Availing themselves of the social room, telephone helpline, library and disco, many had finally found a positive aspect in being gay. For the first time in their lives they had the possibility of a social life: they could make friends, talk openly about their feelings, flirt, even fall in love.

It was liberating and exhilarating, and David's commitment deepened. Why should all these men not enjoy the same rights and pleasures taken for granted by heterosexuals? Surely if the law was changed, and equality granted, the confidence of these men would increase and the prejudices of others decrease?

While in Britain homosexual acts in private by men aged twenty-one or more, had been decriminalised in 1967, in Ireland any act of 'physical intimacy' - which could be interpreted as anything from full sex to a handshake - between men remained a criminal offence, with sodomy carrying a sentence of up to life imprisonment. One leading textbook on Irish criminal law, still in use in the 1980s, referred to sodomy as 'the most heinous and abominable of all crimes', a judgement the author did not see fit to proclaim on murder.

Although the law was rarely enforced, David well

knew that to be categorised as a criminal gave rise to feelings of guilt, fear and a sense of powerlessness among gay men. It pushed homosexuals into leading a double life, left them open to blackmail and made them targets of abuse, both from the public and the police. There may have been no organised police harassment, but gay men were frequently arrested and prosecuted.

The first priority of the Irish Gay Rights Movement (IGRM) was to support defendants who came before the courts; within a few years the number of arrests, especially those by young police officers anxious to accumulate a high score of convictions, had dropped virtually to nil. In most of these cases a young, idealistic solicitor called Garret Sheehan played a prominent and frequently unpaid role. It was a major achievement, but even those whose acquittal the IGRM had helped to secure suffered deep humiliation.

A year after the organisation's inception, David was insistent that if gay men hoped to lead relatively happy, secure lives, the only way forward was to change the law criminalising homosexuality. In a country where it was still difficult to legalise contraception, the likelihood of even achieving a discussion about homosexuality in the Dáil was slim. To bring it about would require constant agitation and media attention. The IGRM would therefore need a public spokesperson.

In 1975, to 'come out' publicly could carry a risk of prosecution, the termination of a career and the disgust of friends and family, and most certainly would be met by overwhelming hatred and bigotry from the public. Only one man in Ireland dared take that risk; soon David Norris was to become the most famous gay man in Ireland.

But his eruption into the public eye was nothing compared to the explosion that was about to occur in his personal life.

David was walking down Grafton Street. It was 1975, a

cold, bright morning in the week before Christmas. As ever, he was thinking about his work for the gay movement, established a full year now and occupying every moment of his life outside Trinity, but that day he allowed himself to be side-tracked, fascinated by the faces of the busy, desperate shoppers who filled the crowded street.

Suddenly one, a short, olive-skinned young man with black hair, caught his attention. David gazed at him, turned round and gazed after him, wishing life was a fairytale so that he could meet the young man, who would be gay and become his companion.

With a sigh he continued on his way to Parnell Square, where he worked until late in the evening, then decided to have a quiet drink at Bartley Dunnes before going home.

For once David Norris was not in the mood to talk - not even about gay politics - so when Edmund Lynch approached him and asked if he would come over and chat to some visitors from the Middle East, he forcefully declined. Rebuked by Edmund, who told him that they would think him impolite, David agreed to say good evening on his way out.

He finished his drink, walked over to Edmund's table, and was introduced to Ezra Yizhak, a twenty-three-year-old Israeli and the very same short, olive-skinned young man with dark hair who had walked down Grafton Street.

David sat down, and in a state of nervous ecstasy began to gabble; only the closing-time bell halted his torrent of silly stories and jokes. The party moved on to Jonathan's, a coffee shop in Grafton Street, where Ezra talked to David and promised to come to the IGRM's disco at the weekend.

It was not until much later that David thought about Joyce's first sight of Nora Barnacle, also a chance encounter in the street. Fortunately, Ezra did not disappoint David as Nora had Joyce, and did come to the

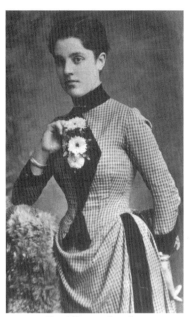

*David's grandmother
at the end of the last century.*

*David's great grandfather,
Richard FitzPatrick.*

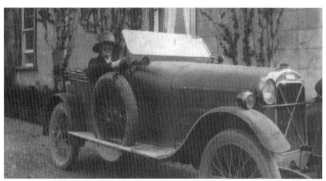

David's mother, Aida Norris

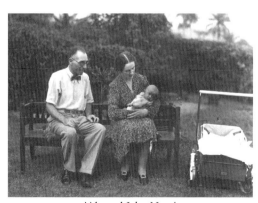

*Aida and John Norris
with 'Little John', 1940.*

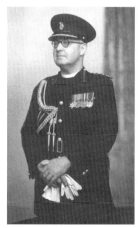

Uncle Dick.

*Miss Connie FitzPatrick,
just after the First World War.*

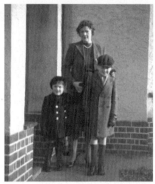

*David and his brother, John,
with their Aunt,
Miss Connie FitzPatrick, in
Sandymount, Dublin.*

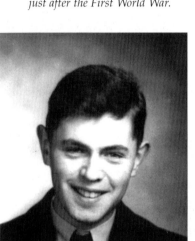

David's brother, John, as a young man.

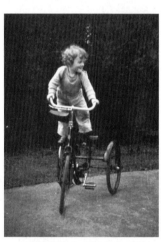

David as a young boy.

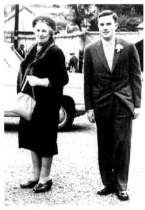

*David and mother, Aida, at the
wedding of David's cousin,
David FitzPatrick, in Dundrum.*

*David and close friend,
David Miller on O'Connell
Bridge, Dublin in 1964.*

disco, although as one of the organisers David was busy and unable to spend the entire evening with him.

At two o'clock in the morning, with a long drive to Wicklow ahead, David interrupted Ezra's dancing to say good night. To his astonishment and delight, the young man politely excused himself to his dancing partner and informed David he would be accompanying him home.

Unaware of the considerable impact he was having on David's life, Ezra remained at Greystones for the remainder of his stay in Ireland. David's house, beautifully decorated but with no heart, suddenly became a home, with blazing fires, music, conversation and laughter. The kitchen, carefully remodelled but never used for anything other than boiling an egg, sizzled with Ezra's Middle Eastern cooking and was filled with the strong scent of piquant spices.

At the age of thirty-one, David, for the first time in his life, had an intimate relationship, companionship, a partner.

'It was a wonderful feeling,' he reminisces. 'Here was somebody I didn't just want to sleep with. I wanted to be with him, enjoy his company, his personality, his conversation, his interests.'

Ezra, he discovered, had been born and raised in Jerusalem. His parents were Iraqis, from Basra near the Persian Gulf, who had settled in Israel in 1951, living first in an immigrant camp, then in an abandoned, empty shop in a dangerous, desolate area once inhabited by Arabs near the Jaffa Gate. Ezra's father, a builder, had put in a door and the family had lived, or squatted, there for three years. Hardly Dublin 4. Theirs was a difficult way of life. While Aida Norris had rung the local shops and given an extensive food order, Ezra's mother had to make everything, except bread, herself. There were no local shops and very little money. With five children to support, Ezra's parents certainly could not afford luxuries such as toys. Still, it was a happy, noisy childhood and the family was necessarily close-knit.

Later they moved into the Jerusalem suburbs; it was more comfortable but financially just as hard, especially when Ezra was seventeen and his father died.

After leaving school, Ezra had taken a few odd jobs until joining the army; like all young Israelis he was obliged to do three years of military service. Once this was completed, it was traditional for young Israelis to go abroad, and Ezra had decided to join his friend and former lover, who was half Irish, on a trip to Dublin. He had never left Israel before and had been keen to improve his very slight command of English.

Although Ezra knew he was gay and had had some sexual experience, the homosexual community and activism he discovered in Dublin was new and exciting. He was also enormously impressed to meet an older man, a university lecturer, who seemed confident and assured and was one of the leaders in the gay rights movement. He liked David's personality, enjoyed their days together and left after Christmas believing he had learned a great deal having a short, fun holiday romance.

But in David's mind, this was no mere affair. It was a relationship. It was love. And he was heartbroken when Ezra left. He watched, disconsolate, as Ezra disappeared among the crowd at Dun Laoghaire, and on the way back to town followed the coast road for one last glimpse of the boat as it took Ezra away.

In the days and weeks that followed, David missed Ezra so much his life seemed emptier than before. The Isaac Bashevis Singer books he began to devour, stories full of Israeli life, relationships, gossip and food, brought some comfort, for Ezra was there on every page, but only a new term at Trinity and the work to be done for the IGRM took David's mind off his longing to be with his olive-skinned young love with the charming smile.

Known at college for his lectures, for his fondness and knowledge of the works of Joyce, for his flamboyance and sense of fun, David Norris was now also the 'Trinity

queer'.

Newspapers were cautiously beginning to publish pieces about the gay movement, but it was a 1976 interview on RTE that gave David instant fame and shook the foundations of Irish society. It was not simply the first time that homosexuality had been discussed on national television; it was also the first time an interview with an openly gay man had been shown. The programme-makers had suggested preserving David's anonymity by filming him with his back to the camera. He had refused, telling them: 'If I'm there saying I'm a perfectly normal, ordinary person, I have to be seen, so people will realise I don't have horns.'

The programme provoked a furore among the public and a ruling from the RTE Complaints Advisory Committee that the programme broke their broadcasting code as it did not represent social mores. The outcry was understandable. Despite the openness that had arrived a decade earlier, this was still a time when even the owner of Bartley Dunnes, the most famous and oldest gay bar in Dublin, was not prepared to admit to an RTE crew that his was a gay pub.

But despite the public outcry and the RTE ruling, the reaction of David's family was fairly calm. His brother John simply realised, and accepted, that David was gay; previously he had assumed it was his younger brother's strong sense of injustice that had made him work so hard for the gay rights movement.

Their first cousin, David FitzPatrick, was equally indifferent: 'No one in the family would have talked about it openly, but I don't remember any climactic event that Norris had come out. It was transitional. When he was involved in the gay business, one wondered if he was gay himself, and came to the conclusion that he was. I didn't find it shocking when he spoke out publicly. But I do remember Uncle Dick saying, 'This thing is buggery!' and I think Miss FitzPatrick was a little shocked'.

Despite the sought-after media attention, the inter-

view had an immediate and devastating effect within the gay movement.

'There was jealousy,' says Brian Murray, a member. 'I think a few people felt David was hogging all the limelight. But by the same token, nobody else was prepared to go public. And nobody else had his degree of facility with the English language, nobody else could be so outrageous that their mere presence would attract attention. David had all those things.'

Jealousies, personality differences and, later, disagreement about the aims of the organisation soon caused a split in the IGRM.

After a successful *coup d'état* by those who wanted simply to concentrate on providing social amenities, David asked a few friends, including Edmund Lynch, Brian Murray and Bernard Keogh, if they would form a group to continue working towards law reform.

In December 1976, exactly one year after falling in love with Ezra, David and his friends set up the Campaign for Homosexual Law Reform under the patronage of supporters such as Hugh Leonard, Victor Griffin and Noel Browne.

The City of David

Mary Robinson was reading an account of David Norris's life as a homosexual.

The last time she had read his prose, she had been amused. As auditor of Trinity's Law Society, she had written an address on law and morality in Ireland in which she had advocated a change in the law on homosexuality, and David had written her a personal letter to express his thanks. It was then that she had realised he was gay.

'Only somebody like me could go out and spend an evening with David and be completely unaware of his sexuality,' she had laughed to herself.

This time she had tears in her eyes.

By now a supremely clever barrister, Mary Robinson had been approached by David with the request that her firm represent him in a case against the State. After TD Dr Noel Browne, had literally been laughed out of the Dáil when he asked the Minister of Justice to reform the law regarding homosexuality, it had become clear to the members of the CHLR that a challenge to the Constitution would be the only method of achieving reform. So David had turned to his friend Mary

Robinson.

'It was the kind of issue that I was very interested in, so it was a challenge, and as far as I was concerned, a very interesting one,' says the President. 'But I do recal! not saying immediately, "Great, let's take a case." On the contrary, I told David that first of all it would be very difficult, and secondly it would expose him to not only public gaze but public ridicule and contempt. It would require from him a very large disclosure of details of his private life and innermost emotional feelings.' Therefore she had asked him to write down why he felt the law had impacted on him in a way that was unconstitutional.

'And he did. He wrote in longhand quite a long account of growing up and gradually realising he was different and so on, and I must say it brought tears to my eyes,' recalls the President. 'From that moment on I was convinced it was right that he would take the case, that he had suffered so much as an individual and people were suffering from the law and the lack of status it involved, that even though it would probably be a very long, hard and thankless road, that it was appropriate that he would do it because it did matter so much.'

That road would have been immeasurably more difficult without the generous support of David's solicitor, the late John Jay of Herman, Good and County, who gave considerable time and effort to the case on a no foal no fee basis.

On 21 November 1977, a plenary summons was issued in the High Court by Mary Robinson on behalf of her client David Norris. It was, indeed, the first step on a very long road.

The case had been ongoing for a year when the members of the campaign decided that as well as working on law reform, facilities were once again needed for gay men. The original disco run by the IGRM had now closed and social opportunities in Dublin were poor.

David was weary from his attempts to find appropriate premises in Dublin when one day, returning

from a meeting with Mary Robinson, he was walking through Dublin's Temple Bar area - now one of the city's trendiest areas but in 1978 completely derelict - when he saw a For Sale sign on a building in Fownes Street.

David discovered that, fortuitously, the buildings happened to belong to one of his neighbours in Greystones, and he laid seige to him and his wife with bottles of Madeira from the Common Room in Trinity. Whether it was the port or David's impassioned speeches that persuaded them, in any case the building soon became his.

'I had about £10,000 which I had put to one side to pay the costs of the legal action. Then I thought, why the heck should I bother? If we lose the case, it will be an enormous amount of money and that wouldn't be enough to cover it. If we win, we get the costs. So I stuck it into the building, for the first year's rent and some renovation.'

David, Edmund Lynch, Brian Murray and Bernard Keogh set up a company to administer the running of the building, which would house an office, a library, a cinema, a restaurant and, on the first floor, a disco. It was called the Hirschfeld Centre, named after Magnus Hirschfeld, a late Victorian medical doctor and pioneer of psychology, who had formed the first-ever real gay rights movement in Germany in 1901 and had run an institute for sexual science in Berlin. Hirschfeld had been largely forgotten when the institute was destroyed and the extensive archives he had collected were burnt after Hitler had come to power. David decided to honour the man and his work, and to remedy to a small extent this burial of the history of homosexuality.

The Hirschfeld Centre opened to the public on 17 March 1979 - St Patrick's Day. But not without problems. Three hundred and fifty people turned up on opening night, with at least as many outside on the street pushing against the doors to get in.

'I will never forget it,' David shudders. 'We hadn't

completed the work, we hadn't tested the dancefloor, and we had serious deflection from the wooden beams. I had to go out and say, "I'm sorry but because we're concerned for your safety I'm going to have to ask you to stop dancing. You're very welcome to stay and have coffee and mix socially, but I'm afraid the music will have to be turned off now."'

His announcement was greeted by groans. Then boos. The atmosphere was turning nasty, and David could see himself staring bankruptcy in the face when one man suggested that at least here were people who cared about their welfare. To David's relief, applause broke out and only half those present demanded their money back.

Fortunately, one of the members of the Centre was a structural engineer who refused to charge for his labour, and once the problems were resolved, the Hirschfeld Centre became a huge success. The disco was particularly successful, attracting 1,500 people at the weekends. The Centre had contacts in the airlines and in the New York clubs and recording studios, and the latest hits were flown straight over from the USA. 'We had them before Studio 54,' boasts David.

Not only records flew over to the burgeoning centre; one man used to bring his friends over specially from Paris, while artists from Ireland and abroad flew in to perform live.

'We had some of those bosomy black women from Motown. We even had a state visit from Elton John on one occasion.'

But David's first encounter with a famous person was fleeting. Running the centre required a total commitment from all the directors. Firstly, it took up much of their time, which was fine by David; his cousins remembered little Bumble as always being bouncy, and David was still obviously full of energy, able to work at Trinity during the day and at the Hirschfeld at night. In addition to the long hours, the directors had to take on any job, however demeaning or unsavoury - unblocking drains, for

instance. This also pleased David; he had always rather liked the Chinese idea - taken to extremes during the Cultural Revolution - that there should not be a complete distinction between intellectual and physical work. Such a distinction, he believed, created barriers between people.

On the night of Elton John's visit, he was on door duty.

'I opened the door and there he was with his entourage, including people with freshly squeezed orange juice and champagne in jugs, because that was what he wanted to drink. He just swept right past me, up to my office, and was entertained there on these bucks fizzes while I was left at the door. I'd said hello, he'd said hi, and that was my meeting with Elton John.'

He was not too disappointed, that time. However, he had been terribly upset once when fulfilling his duties in the Parnell Square disco. The drains had become blocked and David took it upon himself to fix the problem. He removed his mother's ring and left it to one side so that it would not get lost, then lay down on the ground and stuck his hand down the drain. When the job was finished he replaced the grille and looked for the ring. It had disappeared.

'It grieved me very much,' he says. 'It wasn't so much that it was valuable, but I felt here was something of my mother's that I had treated cavalierly and lost as a result. I thought it was insulting to her memory. I was also upset that having done so much to get the disco going, they could have kept their fingers out of my pockets.'

The loss of the ring also meant that David could no longer shock his fellow commuters on the train from Greystones to Dublin city centre.

'The ring was really beautiful, a ruby, set into an emerald which was set into a cluster of diamonds. It had been quite dull when I found it but I had taken some advice and put it in an eggcup of gin overnight and it was smashing. They were really good diamonds. I used

to wear it on my little finger and as we'd draw out of the station I'd make my hand very visible to see the reaction of the rather pompous looking gentlemen opposite because it was a frightfully pansified thing to do in those days. I had great fun.'

Although by 1978 the climate in Ireland had changed somewhat, mention of homosexuality in the national newspapers was still tentative. David Norris was admired and liked by journalists, but the fear of offending readers limited coverage of his activities and of homosexuality in general. In addition, there was little championing of the cause - the homophobia of some journalists ensured they distanced themselves from their subject with a disclaimer along the lines of 'I'm not homosexual myself but ...' So it was a brave step when Michael O'Toole, who had a column called 'Dubliner's Diary' in the now closed *Evening Press*, covered the opening of the Hirschfeld Centre as he would any other first night - no horror, no shock. He simply let the readers of the paper know of a new disco and centre for gay men, thereby creating an impression that it was wholly acceptable.

However, this attitude was rare. Michael remembers the time when David Norris rang Tim Pat Coogan, then editor of the *Irish Press*, suggesting coverage of a new club for young gay people within the Hirschfeld Centre, one that had been organised with their parents, who would bring them there themselves. A mention in the newspaper could, of course, bring comfort and opportunities to young isolated gays who had not come out to their family or whose parents were unsupportive.

'I was in the office when the editor passed on the idea to an editorial executive who promptly phoned the police and asked them what they thought of it,' remembers Michael. 'They said it was a bumboys' club and denounced it, so nothing was written. I often thought of the awful injustice of that.'

Ireland may have opened up considerably, but prejudice and hatred towards homosexuality still abounded.

'I used to get flak from readers for writing about David Norris - anonymous letters and telephone calls, asking to hear no more about this sodomite,' says Michael. 'And that happened even if it wasn't about gay lib but about his passion for James Joyce.'

David's passions and interests were growing; after attending numerous international symposia he had made a name for himself as a Joycean expert, and he was determined to popularise the writer in his native Dublin.

Inspired by his move to North Great Georges Street in Dublin's north inner city, David was also now involved in the recovery of Georgian Dublin. North Great Georges Street was not one of the most desired locations in Dublin, but he had wanted to live there for a number of years, ever since, while still running the disco in Parnell Square, he had wandered into the area by accident while intending to check out a competing gay club which had opened nearby.

'I had never consciously been there before but as soon as I turned the corner, I lost interest in the commercial opposition. I just fell in love with the street.'

In 1978 he finally acquired one of its splendid, although dilapidated, Georgian houses. In doing so he joined in the second wave of restorationists in the street. The original pioneers, who battled on individually for several years before David's arrival, included Harold Clarke of Eason's, Desirée Shortt, a well known porcelain restorer, and the architect Tom Kiernan and his family. When David founded the North Great Georges Street Preservation Society with their assistance in 1979, he found that they had the generous support of the Jesuit community in Belvedere as well as that of long-term activists such as Kevin Cunningham and Ian Lumley from nearby Henrietta Street. The street itself rapidly developed a feeling of community with its social pivots

of Luck Duffy's newsagency in Parnell Street and Fitzpatrick's 'Welcome Inn', described by David as the best pub in Dublin, both great sources of local gossip. Moreover, even the corporation was gradually won over thanks to the generosity of spirit of many officials including Frank Feely, Dublin City Manager and his Assistant City Manager Paddy Morrissey.

It was an exciting time. He enjoyed lecturing; the campaign for homosexual law reform was underway; he was occupied by the Hirschfeld Centre; and he had moved into North Great Georges Street. But, most glorious of all, Ezra was coming back to Dublin.

David, certain that the young Israeli was the love of his life, had been determined not to lose contact with him and had religiously kept in touch - by letter as Ezra did not have a telephone. Occasionally he received a reply. Then one day David's telephone rang. Ezra was calling from Israel.

'I said, "What's it like over there?" and he shouted, "Dangerous" - he was doing his reserve duty in the army and had shinned up a telephone pole to plug himself into the telephone line.'

Ezra, who was living a hippie lifestyle, earning a little cash from casual work as a gardener, could not afford a second visit to Dublin. David was too busy to go to Jerusalem. But he had found a solution.

Moving from Greystones had been sensible. Most nights David was at the disco until two or three in the morning, and now he no longer had to drive home, exhausted, all the way to Wicklow along a dangerously winding coastal road. He had also sold the Greystones house for about five times more than he had paid for it; after putting money aside for the court case - money which eventually found its way into the Hirschfeld Centre - he had more than enough to send Ezra a ticket to come over to Ireland for Christmas. The house in North Great Georges Street was hardly ready for visitors; renovation had begun and walls were being knocked

down, but David wanted to see Ezra as soon as possible.

He worked on his beloved house until the last minute. At the airport Ezra was not greeted by the beautifully dressed man, wearing expensive aftershave, he remembered, but by a dusty, dirty and dishevelled figure, dressed in an old pair of dungarees. David, who cared desperately that the visit was a success, saw the shock on Ezra's face, then realised he had no food in the house - one problem that could be solved by stopping off in Dorset Street to buy a Chinese takeaway. But as they sat on the bare floor and ate their chow mein, he was hurt and disappointed by Ezra's reaction to his Georgian pride and joy. It was an impractical house, uncomfortable and cold; the rooms were too big; and there was just a tiny back garden instead of the expanse of green at Greystones which Ezra had loved. Even the eighteenth-century plasterwork failed to impress him.

'As far as Ezra was concerned, my house was just a kind of tenement building,' says David. 'I remember we went for a walk around to the Basin, where there were little artisans' cottages, and he said, "David, why did you not buy one of these?"'

Despite the inauspicious start to the visit, David and Ezra spent a happy, heady fortnight together. There was just one problem, one which would later plague the relationship: each had a very different view of their relationship. To David, it was one of the great romances of all time. He had been utterly smitten since he had first laid eyes on Ezra, and the intervening years had only intensified his feelings.

'He was the passion of my life. My heart and body belonged to him, absolutely.' Unfortunately, while Ezra's heart belonged to David, his body did not. And the realisation was an enormous shock.

'I was very idealistic, or odd, or sheltered. I had been entirely celibate for about four years and had the idea that Ezra was too while he waited for me to turn up again. But of course he wasn't, and when I realised that, it

caused a certain amount of friction.'

Discovering that he suffered acutely from jealousy, David attempted to console himself with the belief that Ezra had 'nothing except his casual employment and amusing himself. It was inevitable that he was going to explore his own sexuality.'

After the two-week visit had come to an end, David knew that if the relationship was to continue - and he knew it *had* to - he needed to become more realistic, and overcome his jealousy.

Although his house had not pleased Ezra, David had a vision - the restoration of eighteenth-century Dublin, beginning in this street of fine Georgian houses. In the late 1970s, however, very few people would have thought it realisable, much less cared. One of the few who did was journalist Frank McDonald. A few years earlier, after living for a while in New York, he had returned to his native Dublin and was horrified by what he saw.

'I couldn't believe the dereliction, the decay and the wicked wholesale demolition of buildings in the city - buildings that were useful, attractive and a part of essential Dublin - to make way for dreadful office developments. The city was just being casually whittled away and nobody was doing anything about it.'

In 1979, 'Dublin, What Went Wrong?', Frank's series of articles for the *Irish Times*, won him a journalism award, and his continuing concern would later bring him in contact with David Norris as they worked together in a campaign to save the city. For the moment, though, David was concentrating on North Great Georges Street.

An earlier resident, Josephine O'Connell, who was just as passionate about the street, remembers David's arrival. Years after moving in with her husband, Brendan, she was still living with scaffolding and working on their property, which had needed a massive amount of restoration. These were houses that still had outside

toilets, called trustouts, attached to a wall several floors up where courageous, or desperate, tenants would perch precariously on a lavatory set into rotten timber. They were houses where taps dripped so slowly it would take twenty minutes to fill a kettle, where roofs leaked, electricity was an unreliable source of energy and central heating was only a dream.

As their finances permitted, Brendan and Josephine worked slowly on their house, room by room. They had reached the front lounge when they encountered David Norris.

'Every night I would be painting the ceiling, white detail against a red background, and would see this character in the road looking up at my work. I said to Brendan, "There's that fellow again. I want to find out what he's up to."' The next time Josephine saw the 'fellow', she beckoned him in.

'I remember feeling I didn't know him well enough to tell him what I thought of the little brass plate he'd put on his front door - "Visitors by Invitation Only". How dare he come to this street and put it up? What did he think? That we were going to plague him? We were here for years before David arrived and it was our house everyone came to.'

Despite the seemingly petty irritation, David became a good friend, and today Josephine recognises how much she owes him.

'For a long time we had been keen to get an association for the preservation of the street going, but nothing materialised until David arrived on the scene. It was his personality. He was always very enthusiastic.'

It was 1979. David was working on his house, on a campaign to save the street, on the case for homosexual law reform, on the Hirschfeld Centre, and, of course, his lectures. Any free time was dedicated to Miss FitzPatrick; she had become a surrogate mother since Aida's death and David spent most weekends with her at her new home in Sandymount Avenue. There was little time for a

personal life. At least, not in Dublin.

David was at Heathrow airport five hours before the departure of his flight to Tel Aviv. The timeliness was not due to a bad connection from Dublin, nor to his fear of flying or his excitement. It was a requirement by El Al, the Israeli national airline; security was paramount and the checking of passengers and their luggage necessarily thorough. David stood in a most un-British queue. People - some goodnatured, others volatile - pushed and shoved, chattered and shouted. It was a cross-section of Jewry - pale-faced British youths, carrying rucksacks and embarking on a trip to their homeland; families taking a holiday; good-looking olive-skinned Israelis dressed in jeans; elegant, tastefully dressed women; and Hasidic Jews - untidy men with bushy black beards, wearing black gaberdine coats, stockings and hats, with a long curled lock hanging by each ear ...

When David was finally ushered to a desk, a stern-faced security guard asked him the reason of his visit to Israel, whether he had packed his cases himself, left them at any time unattended, or accepted a parcel from a stranger to deliver in Israel. One by one, each suitcase was opened and carefully searched. It would later amuse David that most of the socks, underpants and pyjamas, and all of the ties, jackets, blazers and suits, would be brought back unworn, but even now he finds it difficult to break the legacy from his mother, who had never travelled, or packed for her son, without making sure all eventualities would be covered by plenty of perfectly clean, ironed clothes.

Having satisfied the security guard that he was neither a terrorist nor the unwitting accomplice of one, David had a couple of pints to steady his nerves, and was frisked each time he came back from the lavatory. The tension of the airport was to provide a sharp contrast with the Israelis' easygoing, joyful character.

Everything on the four-hour flight seemed strange: the

kosher meals; the inability of many passengers to remain seated for any length of time; the gruff, guttural sound of Hebrew; and the group of Hasidic Jews who gathered at the rear of the aircraft, swaying and muttering as they prayed. As the plane descended, their feeling of excitement at coming home to their Promised Land was infectious, and heightened David's sense of romance and rapture. He later wrote: 'The sun was behind us, dipping towards the horizon like an angry orange thrown by one of the old gods, when a vague rim of brown baked land became apparent.' And as the plane taxied to a halt at Tel Aviv's Ben Gurion airport, he could see from the window the 'familiar international uniform of ground staff, overalls and ear-muffs. But the faces under the baseball style caps were Phoenician, skin as brown as their dark eyes, hair as black as the runway tar.'

As he alighted, he was hit by the rush of thick, warm evening air and feeling dazed and a little exhausted, eventually emerged from the airport, along a walkway where crowds of excited Israelis hung over barriers, some vaulting over to greet relatives with emotional hugs. And then he saw Ezra. His smile, it seemed to David, lit up the entire airport.

They took a *sherut* - a type of taxi-bus - along a highway of palms, curving gradually up towards the Jerusalem Hills, and littered in places with the pathetic shells of military vehicles, left as a memorial to those who died in the birth of the Israeli nation, past arid stretches of land, by the graceful white arches of the monastery at Latrun that marked the start of the steep climb to the Holy City itself. But David noticed nothing on that hour-long journey; his eyes were closed in reverie, electrified by Ezra's body, wedged in tightly beside his.

Ezra had moved from his mother's home and taken a lease on a little house in Berlin Street, in the fashionable embassy district. Built in the 1930s, his one-roomed abode was tiny. The former wash-house of the exclusive apartments it adjoined, it was about the size of a

comfortable bathroom in suburban Dublin.

'It was the Irish man's dream,' David laughs. 'You could quite literally have a shower, a shite and a shave, and all simultaneously.'

Ezra had hung tapestries on the walls to hide the mould caused by dampness, but David breathed in only the sweet smell of pine trees outside. He was enchanted. In this one room they ate, talked, slept and entertained Ezra's hippie friends. Each morning Ezra would make David coffee and produce the *Jerusalem Post*, and David would sit in the garden reading the English-language newspaper. Later he would hang out the bedding to air under the trees, and in the afternoon shake off the pine needles to make up the bed while Ezra cooked. When the first invitation addressed to them as a couple arrived, David's joy was complete.

'It was the domesticity - sitting together under the trees, chatting away, hugging each other. It was absolute heaven. I didn't really have an affectionate, intimate family life when I was growing up. With Ezra I found it. He was now my family and this was our house. And of course physically I found him very attractive. So it was wonderful, to have somebody you psychologically and emotionally loved, who you also found physically attractive and sexually compatible.'

At first, David was timid about exploring the city on his own, particularly as he had no Hebrew and could not decipher any road signs. But on the corner of Berlin Street and Azza Street was a small kiosk, Confisserie Marcelle, and there he chatted in rusty French to the diminutive owner, an exile from the Seine. He walked around the neighbourhood, along the wide suburban streets with their clean, elegant apartment blocks and leafy green gardens slashed with sudden colours - the red or purple of exotic shrubs, or, higher up among the branches, a yellow mist of mimosa spray. In the warm evening he breathed in the scent of jasmine, then returned home and sat with his partner under a clear sky

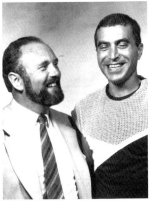

David and Ezra, Ottawa 1983.

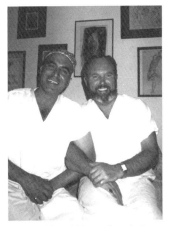

David and Ezra after their wedding in Rahut, 1987.

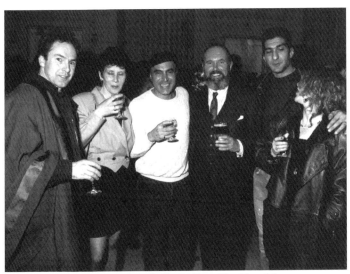

Tony Gregory, Ann Rafferty, Ezra, David and Isaac.

Ezra, 1985.

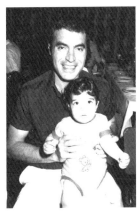

Ezra with his nephew, late 80s.

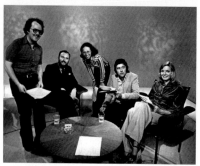

Edmund Lynch, David Norris, John McColgan, Áine O'Connor preparing for a discussion programme in RTE, 1975.

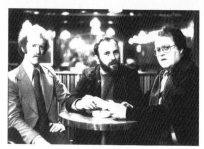

The Hirschfeld Centre. Bernard Keogh, David Norris and Edmund Lynch, 1979.

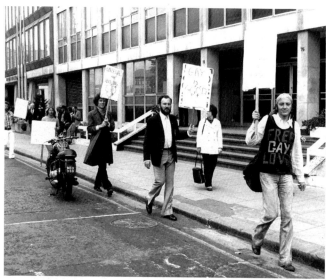

Some of the members of the picket outside the Department of Justice, St Stephen's Green in 1974, to mark a world day of protest against the treatment of Irish homosexuals. David remembers that during the picket a delivery van pulled up outside the Department of Justice to deliver a new carpet to the Minister. Two big delivery men stepped out of the van to unload the carpet and on seeing the picket, one of them said 'What's all this? Bleedin' queers!'. The other retorted 'If it's a picket, it's a picket!'. They both refused to cross the picket line with the carpet and instead, they joined in.

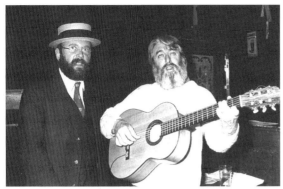

David reading at the Writer's Museum, Dublin.

David with Ronnie Drew.

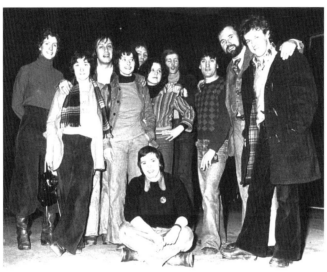

The Gay Sweatshop production of 'Mr X'. Jim Sheridan, David and cast. 1976

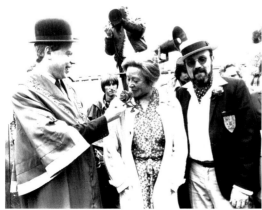

The Lord Mayor of Dublin Alexis Fitzgerald, actress Siobhan McKenna and David.

David dancing at the Joyce statue, Dublin 1990.

With Nicaraguan President, General Ortega,
on his visit to Ireland in May 1989.

With some members of a family from the west of
Ireland at Do You Hear What I'm Seeing? which was
'performed for victims of domestic violence and for
mentally handicapped children.'

David with Mat McCarthy, Maurice Craig
and Michael Keating, 1983.

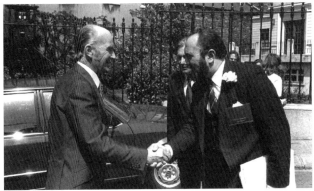

With President Dr Paddy Hillery, June 1982.

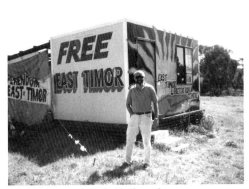

'The Embassy'

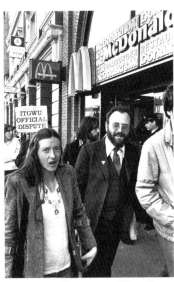

O'Connell Street, Dublin. The McDonalds picket over the union recognition dispute in 1979.

A meeting on censorship, at the Mansion House in Dublin, after the banning of Spare Rib magazine.

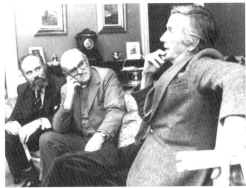

With Noël Brown who supported David as a Trinity candidate for the Senate. and Dean Vicor Griffin

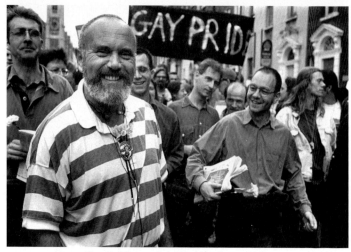

Gay Pride march in Dublin, June, 1993.

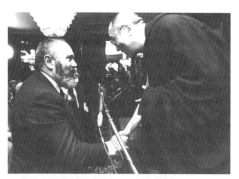

*David With HH the Dalai Lama
during his visit to Ireland in March, 1991.*

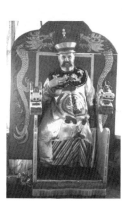

*David on his throne
in Asia.*

*David with Miss
Connie FitzPatrick.*

*David's brother John and
his wife Mary.*

scattered with stars. He was blissfully happy.

When Ezra was not working as a gardener, he showed David the old city, formed from the honey-coloured Jerusalem stone that had absorbed sunlight for centuries and still reflected its brilliance. They wandered through the exotic Arab market, along narrow alleyways, through the different quarters - Armenian, Christian, Muslim and Jewish. From the street vendors they bought food David had never tasted before - pitta bread filled with felafel and hummus - and stopped in a café where they drank strong, dark Turkish coffee and watched Arabs smoking *nargilah* or hookah, and a passing gaggle of Hasids walking with long gandery strides towards the Kotel, or Wailing Wall, the only wall to remain after the destruction of the Temple of the Jews. And behind it, dazzling, was the Dome of the Rock, a site that is holy to Jews, Christians and Muslims.

Ezra and David wandered in the Old City many times but only ever bought some coffee or incense. In preparation for the Sabbath, their shopping was done on Fridays in the Mahane Yehuda, a Jewish market behind Jaffa Street. As evening fell, the rush of shopping gave way to peace as traffic stopped flowing and families gathered together for their Friday-night dinner.

This was David's life for two weeks and every moment was quite magical; he returned to Dublin, in love with the City of David as well as with one of its inhabitants.

Hagirah

If the Irish people had any lingering doubt as to whether David Norris was gay, in July 1980, when his case came to court, he was fully and publicly out, on a national basis. His intention - 'to end the conspiracy of silence' - was clearly a success. For the first time in Ireland, homosexuality was dragged from under the carpet. Puny mentions in newspapers gave way to large-scale, largely positive, media coverage; furtive, knowing nods and winks were replaced with frank discussion; the belief, or wish, that homosexuality was non-existent could no longer be accepted. At last, the realities of life for gay people were made known.

As Mary Robinson had predicted, legally the case was extremely difficult, despite enormous help from her client and his supporters. Her leader, Donal Barrington SC, devised much of the actual legal and conceptual approach to the case, but became a judge before the High Court hearing. Although he was replaced by Garrett Cooney, a greater burden now fell on Mary Robinson's shoulders, at a time when she was also taking silk.

'We worked together but David was very creative in his constitutional thinking; he was the one who was

leading the actual way in which we would frame the arguments and present the case,' says the President. 'We did a lot of research on other jurisdictions, notably the USA, and received a lot of help from his colleagues in that research. It was a case where the client was able to be of great assistance in suggesting potential expert witnesses, books and so on.'

The team had closely followed the *Dudgeon* case in Northern Ireland, which was also setting a legal precedent. The 1967 British law reform had not been applied to Northern Ireland, and in 1975 police harassment involving the arrest of twenty-three gay men had prompted the Northern Ireland Gay Rights Association, with Jeff Dudgeon as plaintiff, to challenge the anti-gay laws at the European Court of Human Rights. In July 1977 the Northern Ireland Human Rights Commission had recommended that the laws be reformed. Despite an announcement that it would implement the recommendation of the Commission, the British government later argued in Strasbourg that the opposition of the Unionists and the Catholic Church justified their refusal to reform the law.

In *Norris* v. *The State*, the Irish government called no witnesses to back up its case but argued that sexual relationships outside marriage were unacceptable and that the state should do all in its power to stop the spread of homosexuality. However, in delivering his judgement on 10 October 1980, Mr Justice McWilliam seemed to accept most of David Norris's case: that there was a large gay population and 'no foundation' for the common negative stereotypes, and that the discrimination experienced by gay people was reinforced by the law. David was convinced they had won, but at the last minute there was a swerve in the judgement.

'The judge had accepted all our evidence that gay people were a significant minority, not less intelligent than heterosexuals, not child molesters, not morally depraved ... it was like a roll call of gay rights. Then

suddenly at the end he said that, nevertheless, because of the Christian and democratic nature of the state and constitution, the court had to find against. So I at least felt we had won a moral and intellectual victory. The judge just felt his hands were tied.'

Edmund Lynch remembers the general feeling of the team. They were disappointed but not despondent.

'We knew we would go to the Supreme Court, and if that failed, to Europe. We felt confident we would eventually win.'

By now David Norris had firmly established himself at Trinity College; few lecturers were as famous or popular. He was also becoming known not only for his interest in and knowledge of James Joyce, but also for his performances of the writer's works. His first public performance had been in the 1970s with Ronnie Drew, a member of the Dubliners folk group, in the Players Theatre at Trinity. David had acted out extracts from Joyce's works while Ronnie sang Dublin street songs. The set had been designed as a bar with stout, supplied by Mrs Galen Weston, owner of the Bailey pub, served to the audience during the interval.

It had been David's first theatre performance. And he had loved it.

Although he is probably gifted enough to have become a professional, acting is not a lone craft and David always knew he was an individualist who needed independence. Also, like many entertainers and people who find themselves famous, he now had a larger ego to feed: a one-man show in which he held centre stage provided him with perfect fodder.

However, occupied by his work for the Hirschfeld Centre, the court case and the renovation of his house, his performances of Joyce were limited to lectures. And this was how Michael O'Toole, the journalist who had written about the disco and was now a mature post-graduate student of Anglo-Irish literature at Trinity, first en-

countered David Norris, the Joycean expert and Michael came to be instrumental in the genesis of the one-man shows.

David had never regarded teaching as a mere transmission of facts. He was quite unlike lecturers who read in a monotone, sometimes year after year, prepared notes, sometimes year after year, trawling through certain texts in preparation for an examination. Instead, he attempted to transform a dull afternoon into a magical experience, to convey his intense love of literature, to arouse his students' own curiosity and enjoyment. His lectures were lively, physical, stimulating spectacles and were frequently rewarded by applause. His lectures on Joyce, especially, were captivating.

'I cannot imagine a better lecturer for young people coming to Joyce,' says Michael. 'Just to encounter David would be a blessing, because he would fire anyone with enthusiasm. His lectures were effervescent. He read so beautifully, so powerfully and so humorously. And as he read, he was several people at once; he acted out all the parts. A few people didn't like that style - ultra-serious students to whom the notion of actually enjoying a lecture was anathema - but I thoroughly enjoyed it.' And, thought Michael later, so might the members of the Irish Countrywomen's Association, to whom he was teaching a summer course in media studies and he asked David to give a reading.

'It was a roaring success. I knew the minute he had finished that he had a valuable commercial property which he could do on a big scale. I told him people would come and pay to see it.'

Subsequently, many people did pay to see it, donating money to charity in the process. The first occasion was when Michael asked David to perform the show to raise funds for a shelter housing victims of domestic violence.

'We raised a massive amount of money and then he did the show a number of times afterwards for various charities I was involved in. He was always immensely

generous. He never said no, always performed with zest, did whatever was asked of him. No matter how tired or busy he was, he always found time to give.'

The show, entitled Do You Hear What I'm Seeing?, was performed for victims of domestic violence and for mentally handicapped children; it helped to buy a specially adapted van for a woman in the west of Ireland who had adopted severely disabled children; it raised money for patients with AIDS; and later it was to help fund a cause more closely related to Joyce himself - the James Joyce cultural centre. His performances helped a great many people, but they were also a critical success. The *Evening Press* referred to it as 'spellbinding' and 'superb', as well as a 'phenomenon'; the *Jerusalem Post* even covered a performance given on one private trip to Israel, to an 'enraptured' audience. Those who bought tickets to see David's shows would have known he was performing to raise money for a particular cause. But few people since have any idea just how much David Norris gives to others.

The relationship with Ezra was ongoing but unsteady. David was still head over heels in love, and celibate, but Ezra was clearly uncommitted. Frequently his letters would dry up, leaving David feeling wounded and insecure.

'I had a good job, my own house and financial freedom, but Ezra had a sexual power because I didn't see myself as attractive and I saw him as terribly attractive and knew he was to others as well. And it was difficult keeping in touch by letter. It's not the same as being with someone or living together. But I decided whatever was happening, I was going to continue loving Ezra and find as much common affection, love and friendship as was possible and develop that.'

So David would keep writing even when he received no reply. Then, signalling Ezra's latest affair was over, he would receive a letter.

'On the day it would arrive, with his rather spidery writing and an Israeli stamp stuck on at a crazy angle on the envelope, I would be as high as a kite for a week,' he says.

David's love, tenacity and the growing bond between him and Ezra kept the relationship going, and the year after David's first visit to Israel, Ezra came back over to Dublin. His English was steadily improving; as he says, David is after all a teacher.

'I learned a lot from him, and every time I didn't understand something I could always stop him and ask for an explanation. He was very patient.'

However, David's use of the English language is particular.

'He speaks *hocht* English. I learned words like "wireless" instead of "radio" and "spectacles" instead of "glasses". But for a long time I misunderstood "spectacles". I had heard "testicles". I kept practising the word in Dublin and he never corrected me. But I thought it was very funny,' Ezra says.

David, he soon realised, loved to shock. Although aware that Ezra was a little shy and inhibited by the language and that therefore social events could be a strain, he could not turn down all his friends' invitations. Besides, it was fun to go out as a couple, and he knew many were wondering what he saw in the Israeli. Ezra was good-looking, certainly, but between them there was the language barrier and an enormous difference in background, education, finances, and employment - Ezra, with David's encouragement, had trained to be a plumber.

'On one occasion,' David remembers, 'Ezra was talking about his mother and said she worked in the university. People automatically assumed that was the link between us and asked him what department she worked in. He said, "On Tuesdays she works in the history department, on Wednesdays in the mathematics department, on Fridays the physics department." They were all terribly

impressed, all these qualifications, and asked what exactly she did. Ezra said with great pride, "Oh, she cleans the floor." I thought it was simply wonderful.' From an early age, David's experience as a homosexual had taught him to accept difference, and he hated snobbishness. There was no need to explain to anyone else that although Ezra had not received a university education like his siblings, he was intelligent, cultivated and widely read.

'His one blind spot was classical music,' says David. 'He was never the slightest bit interested in it and he used to amuse me if the wireless was on in his apartment or somebody was playing a record, I would say, "That's lovely, Ezra, what is it?" and he would always answer, "Scheherazade." It was the only name of a classical tune that he knew.'

It was wonderful to spend time together, but if David had competition from other lovers, Ezra was forced to share David with his work and campaigns. Although he may not have appreciated David's vision for North Great Georges Street, Ezra understood immediately, and has reminded David consistently since, that he did not give himself the chance to have a personal life. It could also be argued that without a full-time relationship, David has always used work to distract himself.

A more permanent relationship with Ezra might have been possible if either could have emigrated. Caught as he was in the middle of his court case, and too close to Miss FitzPatrick, now in her eighties, to consider moving to Israel, leaving Ireland was impossible for David. But Ezra made an effort to settle in Dublin. It lasted two months.

'I live by instincts and I felt it was wrong,' he explains. 'The language, the weather, the culture ... it was too difficult. I found the people non-aggressive, very warm, very welcoming, but I will never be Irish. I don't want to be Irish. You have to adapt if you go to a new place but I didn't want to change myself, the way I speak, think. It

wasn't for me. My roots aren't there. I would have lost half my life, my life as an Israeli.'

David was disappointed but understood Ezra's difficulties. 'We had no problem conversing because we had a psychological link, but he did find it difficult to talk to others. And he got quite homesick. He's devoted to his mother and missed her terribly.'

It was personally upsetting but the experience reinforced David's commitment to legal reform.

'There are so many obstacles against gay relationships, particularly if your partner is not a national. You can't give the relationship a chance. You can't marry; you don't have the right to introduce your partner into the country. Even if he was Irish it would be difficult. The most subversive thing a gay person can do is set up a long-term relationship with one partner. Society has always found that much more upsetting than the idea there were people having sex, which is why to a certain extent gay people are promiscuous. It's very disturbing for conventional people who are conventionally happy with The Family. They don't like to think someone else can be happy in a different way. That is not the way life is supposed to be. And the result is a lot of gay people find their way to public lavatories or the back rooms of bars in Amsterdam, or Phoenix Park Society encouraged homosexual promiscuity because the message you're given is have a sexual life if you want it, but have it furtively, anonymously, discreetly, just don't look for dignity and emotional rapport.'

David and Ezra had no choice but to remain physically apart, although emotionally they were, and still remain today, very much together. 'Ezra was part of my life,' says David now. 'I would talk to him in my head, wonder what he would think of this, what his attitude would be about that, what he would be doing ... He became a very important touchstone in my life.'

David was just as much in Ezra's thoughts. 'I can't remember a day in my life when he wasn't in my mind,'

he says.

Both looked forward to David's annual visits to Jerusalem. By now Ezra had moved from his damp, dark little one-roomed house to a bright, airy apartment in a suburb called Ramot. The apartment would be filled with the smell of exotic spices and herbs as Ezra cooked Arabic dishes, served with salads and red rice or couscous or even pitta bread that he made himself. David loved Ezra's cooking.

'He was always very greedy. Even more than me,' laughs Ezra. 'Very greedy indeed.'

The influence of Ezra's Iraqi background could be seen not only in the food he cooked, but also in his dress and taste in music; he wore jellabas and listened to Arabic singers such Oum Khalsoom, Fairuz and Farid Al Atrache. Although David became accustomed to the music, and took to wearing the same long, flowing garments of the Hebron Arabs, he never assumed Ezra's flair for cooking. He entertained very rarely, and then with little success.

'I remember going to David's house in Greystones once for dinner,' says Bernard Keogh. 'He had forgotten to buy food but didn't tell anyone. We all sat down at the table and he came in with enormous white dinner plates, and sitting in the middle of each plate was a little poached egg. I think he was one of the first to introduce the idea of *nouvelle cuisine* into Ireland.'

In Israel, David would do the washing-up, standing at the kitchen window, watching the evening light change from blue to purple, and the forest-clad hills across the valley darken and begin to shimmer with discreet light from paths and scattered houses. On Friday evenings he would catch a glimpse in the distance of the last few buses leaving by the highway for Tel Aviv as the traffic slowly came to a stop to observe the Sabbath.

Although he had always been aware of Jewish customs - there had been Jewish children at his school - and of course familiar with Bloom in *Ulysses*, David now

found that his knowledge and affection for the Jewish religion had grown. He loved the way families gathered together to welcome in the Sabbath, saying blessings over two candles, plaited bread and wine before sitting down to eat. 'When you take part in Jewish rituals you see how very close the religions are and how Christianity really took quite a lot from Judaism,' he says.

He himself was, and is still, a practising and committed, but not fanatical, Christian. On one trip to Israel he was staying a night at a little hotel on Hayarkon Street in Tel Aviv. Breakfast one morning was interrupted by the intrusion of a young American, brash and born-again, eager to share the gospel of his personal encounter with Christ. The only other people at breakfast were an elderly couple. As a Christian himself, David felt deeply embarrassed and, when the evangelist left, apologised to the old man, who smiled gently.

'Thank you but I have had worse. I was born in Germany. We lived in Munich. I lost my mother, my father, my brother, my sisters and my first wife. I survived myself only by accident. The day that they came for my wife and myself, I was out at the dentist. He was a Dr Goering, cousin of the Reichs-Marshal. He continued treating Jews but they couldn't touch him. He told me to go back the next day for a filling. When I got home the Gestapo were waiting. They took me to the police compound where I was to be held, awaiting transport to the camps. The next afternoon I was called out. I thought it was the end but it was a messenger from the dentist. They gave me back my clothes. I was released for my appointment. The dentist said nothing. Once my filling was done I left the surgery and made straight for the station and got on the first train. I escaped. It was a miracle.'

It was an extraordinary tale, but looking at the old man and his wife with their simple courtesy, David knew it was true that Israel has many such stories and that we are bound to listen.

'It is a place to which the heart is drawn inexorably.'

Despite the many distractions of his work and his personal life, David, his hardworking supporters and the legal team had not ceased in their efforts to reform the law on homosexuality, and in 1981, a ruling in the *Dudgeon* case gave them some hope. A total ban on homosexual conduct, the Court in Strasbourg decided, was contrary to the Convention on Human Rights. Despite hefty opposition from the Catholic Church, Ian Paisley's church and party, the Official Unionists and the Orange Order, law reform for Northern Ireland, based on the 1967 model operating in Britain, was passed by the House of Commons in October 1982. Following an appeal, *Norris v. The State* was set to be heard in the Supreme Court in April of the following year.

David, exhausted from all the commitments in his life, decided that a visit to Ezra would recharge his batteries before he had to appear in court, and he flew to Israel hoping to rest, relax in the sun and receive some much-needed care and attention.

After a day's travel, he was relieved finally to be sitting in Ezra's house, sipping a cup of tea and chatting, delighted once more to be in the company of the man he loved. He was in no way prepared for the bombshell that suddenly hit him.

'David,' said Ezra. 'I have to tell you. I do not find you physically attractive any more.'

David did not bother to unpack; he returned immediately to Tel Aviv. He could not stay in their little house, sharing the one bed. He did not even want to stay in the same city. In Tel Aviv, he booked into a hotel and soon had visits from Ezra. 'He would be dressed up to the nines, with one glove on and carrying the other like something out of Marcel Proust.'

These formal visitations did little to ease David's hurt and anger, and he threw himself into Tel Aviv's gay scene. He found to his surprise that he had no shortage of

admirers, and this restored a little confidence in his own sexual power - a confidence which had never been terribly high and which now he felt had entirely disintegrated. One night, after spending the evening with a very good-looking ballet dancer, David decided he wasn't that unattractive after all.

'I got absolutely plastered and at four o'clock in the morning I booked out of the hotel, got into a taxi and went all the way to Jerusalem, to Ezra's house. I just kicked the door in and said, "I'm not as bloody unattractive as you seem to think," then conked out on the bed.'

He and Ezra made up, and would afterwards jokingly refer to David's departure to Tel Aviv as his *hegirah*, an Arabic word meaning 'emigration', referring to Allah's journey from Mecca to Medina. Nevertheless, he returned to Dublin wishing that Ezra would soon be middle-aged, bald and fat. 'Then nobody else would want him and I could love him all for myself.'

A few weeks later he appeared in court.

The outcome was disappointing. In a majority 3/2 judgement the Supreme Court found that the laws regarding homosexuality did not contravene the Constitution. In delivering the judgement the Chief Justice began by stating there were 'a large number of people in this country with homosexual tendencies', and that should decriminalisation come about, the small number of people who were exclusively homosexual would entice this larger group into 'more and more deviant sexual acts to such an extent that such involvement may become habitual'. Many more people, he stated, would have to endure the 'sad, lonely and harrowing life' of the exclusively homosexual man.

'We were obviously all very disappointed,' remembers Mary Robinson. 'But we were heartened by the strength of the dissenting opinions; they both encouraged the further step of going to Strasbourg. The main pressure would be the length of time before the hearing. I think

that was hard for David.'

Certainly another court case, this one in Europe, would mean more years of publicity, and abuse, and as gay activist Kieran Rose points out, David did not even have the full support of the gay community itself. 'There were more radical groups who felt that direct action was more important, that this long legal action wasn't getting us anywhere and was removed from people's lives. David had to put up with all those issues as well as the court case. It must have been a phenomenal strain on him.'

If it was, nobody would have known. David Norris seemed habitually happy, persistently good-humoured, grossly extrovert and as entertaining as ever. Michael Moran, still a friend and at the time running a garage, remembers how at that time David would come and visit. 'He had a big Rover and he'd get out, wearing this huge black hat - it wasn't a daily sight in the garage, people arriving wearing big hats. Then he'd say loudly, "Hello, Michael" in a broad Dublin accent. I'd cringe in case there was someone nearby who spoke like that, and I'd think, please, David, just get back into the car and start again. But it was only momentarily embarrassing. He was such good fun.'

David, who declares he possesses absolutely no taste in clothes, had by now exchanged pink for pinstripes. 'I think he always took a pride in his appearance but at one stage he had a passion for waistcoats,' remembers his brother John. 'They were some of the most peculiar things you ever saw.'

David FitzPatrick wondered if his cousin was modelling himself on Uncle Dick. 'Although he [Uncle Dick] was a cleric, he didn't always dress like one; he was always very stylish and turned out in a hat. And he would do the most outrageous things, like going into St Patrick's Cathedral and asking if it was all right if he smoked.'

When Uncle Dick died in 1984, the two cousins went

over to England for a memorial service in a little Norman church in the village of Ashwell, in the old county of Rutlandshire. On the way up to the wooden pulpit, the elderly pastor dropped a sheaf of papers on which was obviously written his funeral oration. Unfortunately, he picked up the scattered sheets in the wrong order. 'Near the end of his sermon,' recounts David, 'he reached a kind of emotional climax, leaned over the pulpit and asked a flight of rhetorical questions: "What is it all about? What does life mean? Where is our brother, Richard, now?" He looked down to page seven to see where Richard was and must have found the wrong page, because he was a bit flustered for a while. Then he collected himself, looked out into the congregation and said, "Well, to be honest with you, I haven't got the slightest idea. And I very much doubt if any of you have either." My cousin and I keeled over with laughter, which horrified all these frightfully correct British people because we weren't acting as grieving relatives should. But I thought it was an uncharacteristic and very engaging moment of theological honesty and Dick would have loved it too.'

Family and friends had by now become used to David's own wild behaviour, which never changed even when he became an elected representative of the State of Ireland. Joe O'Toole, who shared an office with David, would remind him that he was using a telephone, not a megaphone, and thought that perhaps Ezra could hear David's loud voice in Israel anyway. And he may have been wearing a three-piece pinstriped suit, but the wild 'jungle boy' would leave his office in Kildare House and slither down the brass handrail to reach the street.

'He keeps the appearance of being this terribly straight-looking individual and then does the most bizarre things,' says Brian Murray, his friend and colleague from early IGRM days. 'When David drinks, he really drinks an awful lot, and he's just uncontrollable. I

remember once leaving him in the Senior Common Room after the Trinity Ball, at about five o'clock in the morning; he was pissed out of his head and crawling on all fours towards a couple who by that stage weren't fully clothed. I don't think David even knew where he was.'

Without doubt, David was extrovert - and excessive: passionate about Ezra, wholly committed to causes, determined in the extreme, David could not be described as half-hearted about anything.

'We started smoking when we were about fourteen, remembers Michael Moran. 'He'd go down to a little shop in Sandymount where you could buy loose cigarettes, one or two at a time. Since then David has given up on a regular basis, then gone back on them ten times worse than before.' It is a habit that continues, regardless of ill health.

Fortunately David never took to drugs, although an attempt was made to introduce him to cocaine. One evening, while he was on the door at the Hirschfeld, a fight broke out between two guests. David leaped over the counter to intervene, and while separating the combatants was punched in the face. It was the night of the Trinity Ball and a friend, thinking David looked a little sorry for himself, offered him a free ticket.

He accepted with alacrity, found a stand-in doorman and made his way to the Common Room at Trinity. Fortunately all the lecturers, suitably dressed in evening wear, had imbibed enough not to care that David was still dressed in tight white jeans, open-toed sandals and a fetching yellow fishnet tank top.

After a few drinks himself, he was delighted when a man he was talking to put his arm around him and led him outside, saying, 'I think I know what you'd like, am I right?' David nodded, closed his eyes and put up his little face for a nice, romantic kiss - whereupon something was stuck up his nose and he sneezed. On re-entering the Common Room, he fell fast asleep. It was not the habitual reaction to cocaine, but he never tried to discover if it

would work at a second attempt.

Friends learned rapidly that David's outrageous behaviour could be embarrassing. 'You couldn't bring him anywhere if you were really concerned about other people, because you never know what he's going to do. But,' adds Brian, voicing the opinion of all his friends, 'that's one of his endearing characteristics.'

David is unrepentant, even though at times Ezra did care, very much, what others thought. While David gave the impression of respectability in his dress, and then behaved unpredictably, Ezra, in jeans and T-shirts, relaxed and hippyish, was, according to his lover, actually quite prim. 'I was guilty of lots of lapses of decorum, like letting bellows of laughter out in a café,' David says. 'Ezra would be very shocked. He would get up to all kinds of roguery in the bushes, but you don't break decorum.'

While not entirely approving of David's behaviour, his aunt Miss FitzPatrick became resigned to it. 'I give out an awful lot to him because he likes to laugh and I tell him to have sense. I tell him, "At your time of life, I do wish you'd get sense," and he answers: "I hope to God I never will." That's the sort of person he is.'

After the deaths of Granny Wiz and Aida, the bond of affection between Miss FitzPatrick and David had become even stronger. His aunt was now in her mid eighties, and David would spend many nights at her house in Ballsbridge. They disagreed often, exasperated one other frequently, but liked each other's company enormously. Any tendency by David towards self-importance would be instantly rectified by a cutting remark from Miss FitzPatrick.

With much of his four-storey house in North Great Georges Street splendidly restored and beautifully decorated, David was keen to show it off to his aunt. She looked around each room, surveying the carefully painted cornices, the paintings and heirlooms, the exquisite pieces of furniture and the tasteful furnishings.

Her eyes, still seemingly as sharp as ever, took in the accumulation of objects - hand-painted eggs, carved wooden animals, golden cherubs, decorative plates, cushions, cigarette boxes, vases ...

'As far as I can see,' she said dismissively, 'the only things you have that are any good are the few old bits and pieces I gave you. And who's your cleaning woman?'

David told her it was Mrs Kiernan, and that she was very good.

'She must be,' retorted Miss FitzPatrick. 'If it was me, I'd refuse to come in with all the frippery and rubbish you have all over the house. It must be impossible to dust.'

David loved her even more.

Miss FitzPatrick's opinion was shared by Ezra. 'I remember once we were in a café in Paris. I liked the ashtray and said, "David, do you mind? I'd like to steal it." He told me not to, then spoke with the waiter who came over with two ashtrays for us to take away. Of course, I don't have them. David does. He was always obsessive about collecting things. I think it's a sickness,' Ezra jokes. 'I would think of suicide if I had such a mind. He wouldn't do it if he lived in the Middle East because it's so dusty here, but maybe he needs to be surrounded by memories.'

Since Ezra had moved into his apartment in Ramot and installed a telephone, David would ring him every Friday night. But in 1984 the distance between them became unbearable. Ezra's sister had emigrated to Canada; he had decided to follow her and even found a job. When David visited him there in July they did not just celebrate his birthday; after a trip to a photographer and the exchange of rings, they also celebrated their engagement.

Their happiness, however, was marred when Ezra received a letter from a former lover. Fortunately, David knew instinctively not to vent his jealousy, and fortunately, the letter told Ezra that this man, Rafi, was in

hospital in Tel Aviv. He was the first AIDS patient in Israel. After eight months in Canada, Ezra went home to look after his sick friend and David went back to Dublin.

David was as busy as ever. Now that his house was habitable, if not entirely finished, and the residents' association was campaigning vigorously against the demolition of other houses in the street, he joined a committee formed to attract widespread attention to the crisis facing Dublin's heritage.

'The dereliction of large areas in the inner city was overwhelming at that stage,' remembers Frank McDonald. 'And the Corporation was driving road plans through historic areas while refusing to admit there was even a problem.'

The Dublin Crisis Conference was held in the Synod Hall and attended by the then Taoiseach, Garrett Fitzgerald.

'We just tried to make an impact on the people who made decisions about the city,' says Frank McDonald, a member of the committe. 'I don't know how far we succeeded but it certainly focused public attention on what was wrong.'

David's work was going well, if occupying an inordinate amount of time, and he was approaching the tenth anniversary of his relationship with Ezra. It would, of course, have to be celebrated and he booked a seat on a flight to Israel. By now Jerusalem had become his second home.

Senator David Norris

The boy who had been so excited to take the ferry by himself on his way to Cleethorpes was now an experienced traveller. He had spent much time on aeroplanes, attending conferences on behalf of the gay movement, speaking at international James Joyce symposia and holidaying, often with Ezra. David, he says, is a man of the world. 'You can put him anywhere, in any city, and know he will manage.'

Certainly David was now as familiar with Jerusalem as any of its inhabitants, and he had also explored much of the narrow country of Israel: the city of Tel Aviv, a unique blend of Mediterranean beach resort and cultural and financial centre; Haifa, in the north, a seaside resort, busy port and industrial centre set behind the stunningly beautiful Carmel mountain range; and the salty Dead Sea, on the eastern edge of the Negev, some 405 metres below sea level.

He had made friends and come to know Ezra's family, although it had taken time to build a relationship with his lover's mother.

'Like every Jewish mother, she thinks her children are angels and corrupted by bad boys,' Ezra laughs. 'One day

117

I told her that maybe I am a bad boy too and she stopped blaming David and came to like him.'

When David and Ezra celebrated the tenth anniversary of their relationship in January 1986, the gathering included family and friends. They blew out the ten candles and cut the cake together, and as they were washing up after the party, Ezra said, 'David, why limit it to ten? Why not for ever?'

David's deepest wish had come true; after a decade of non-commitment on Ezra's part and jealousy on his, his tenacity had finally been rewarded. They might have to conduct their relationship while living in separate countries, but in spirit they were married. After a glorious 'honeymoon' trip to Egypt together, he returned to Dublin, on a high.

Throughout the years David had continued to ring Ezra on Friday nights. Sometimes the conversation was basic - just enquiries about each other's health and the weather - but at least the calls served to keep the relationship alive, to remind Ezra of his presence, to make it more difficult for Ezra to lead an independent life. His gift of an answerphone to mark their tenth anniversary was similarly self-serving. Even if Ezra was out, David's voice would later be heard in his home.

But when, on his return to Dublin, he next rang Israel, he received no reply. The answerphone had not been set up. David rang again and again, worried that Ezra might have been taken ill. Finally he phoned a mutual friend who gave him another number to ring. This time the answerphone was working but the voice that had left the message was not Ezra's. It was deep, rich and spoke in Hebrew.

David continued ringing, leaving dozens of messages, but Ezra never called back. Eventually the man whose voice was on the answerphone broke in as David was leaving yet another frantic plea for Ezra to get in touch.

'Listen,' he said, 'Ezra's not telling you but I don't

think it's fair. I think you should be told. I'm Isaac. I'm a friend of Ezra's. I'm living with him.'

David put down the receiver. Within minutes tears were rolling down his face and he had opened a bottle of whiskey.

Isaac Mesillati was twenty-four, an Israeli, cultured, academically gifted, tall, muscular and devastatingly handsome. He lived in a beautiful apartment in the most expensive area of Jerusalem, and had contacted Ezra on the suggestion of a former lover who thought they would be well suited. Two days after their meeting, Ezra had moved into Isaac's apartment. He had not mentioned David and their ten-year relationship, and was unwilling to talk about the man who was leaving messages on his answerphone. It was as if David Norris had ceased to exist.

Six months later, Ezra was forced to acknowledge that he did. David was in Jerusalem.

Those six months had been hell for David. Always a fervent Christian, now he drew even more on his religion for support, and every evening he anaesthetised himself with whiskey.

'I was in despair. I was desperately lonely and desperately unhappy. I'm a jealous person anyway, but it was the separation that was killing me - not being able to talk to Ezra, to be with him, to touch him. I felt I was suffocating. It was the collapse of my world.'

A few friends were aware there were problems in David's relationship with Ezra but his misery was mostly self-contained; he still retained an outward show of absurdly good spirits. His lectures were as lively as ever, and his work for homosexual reform, the Hirschfeld Centre and the inner city intense. If he had confided in friends they might have advised against a trip to Jerusalem, but David decided not to waste the ticket already booked - a ticket that would keep him in Israel

for six weeks during the summer vacation. He also decided not to contact Ezra.

For the first time in ten years, David arrived at Ben Gurion airport without his lover waiting to greet him. He made his way, alone, to the university in Jerusalem where he had signed up for an *ulpan*, an intensive course in Hebrew.

It was strange to be there without Ezra by his side. Daivd missed his wide smile, his lively conversation, the lovely atmosphere that always seemed to surround him. Fortunately, most days were spent in a classroom absorbing words of a language that sounded so familiar now, and most of the evenings were spent with the other students, mostly new immigrants, or with friends he had made on previous visits. On free days he wandered alone around the Old City, stood and watched the bowed, covered heads of those praying in front of the Wailing Wall, stared up at the Tower of David, sat pensively in a café in this city steeped in history. It was miserable, unbearable. Yet David resisted any temptation to call.

A few days before he was due to leave, David was walking along a street near the university when he passed a big, good-looking, muscular man holding a sports bag.

'I don't know how but I had an electric feeling that it was Isaac. I turned round and he was looking back at me.'

It was indeed Isaac.

'It was a Saturday afternoon,' Isaac himself remembers. 'I had been swimming in the YMCA, and when I got home I told Ezra I'd just seen David Norris in the street. He said, "It's impossible. You don't know what David looks like," but somehow I knew it was him.'

A few hours later Ezra's telephone rang. After the strange experience in the street, David had felt compelled to call and he suggested they meet for a drink in the bar of the King David Hotel that evening.

Ezra was incredulous but delighted. 'Oh my God,

David, you in Israel, I don't believe it. Isaac tell me but I don't believe it.'

That evening, at seven o'clock, David met Ezra and his new partner.

'It was exciting but strange. I was very jealous but Isaac was so nice. He went out of his way to be kind and hospitable and invited me to dinner the following evening.'

Isaac felt sorry for David. 'He was suffering, really suffering. I think he felt he'd lost Ezra to a much younger, and if I can say it, a more handsome man, with a luxury house. At the same time, he was a bit pathetic and it seemed to me masochistic to come to a city that screams Ezra wherever you go but you can't touch it.'

A few days later David returned home with a basic knowledge of Hebrew and a broken heart.

As ever, he was drowning in work, spending his days at Trinity and his nights at the Hirschfeld Centre. One evening in November 1985, as people were beginning to arrive at the disco, David was sitting in the office on the top floor of the building when he noticed some sparks, and immediately suspected that the burglar alarm had short-circuited. With a fire extinguisher under each arm he climbed through the flexiglass dome windows overhead and clambered on to the flat asphalt roof. It was ablaze, and clearly not by accident. Petrol had been poured over the roof. Nearby stood two milk churns full of explosives and a barrel of petrol, and used firelighters were strewn around. It would have been a matter of minutes before the milk churns exploded, blowing the barrel apart and sending down sheets of flaming petrol.

'I went on automatic pilot,' David remembers. 'I just squirted away with the fire extinguishers until the flames were out, then called the police. Masses of them came, which disturbed some of the clients who thought they were going to be arrested. But they weren't going to be cheated out of their disco, so it went ahead.'

When the police had left and David was back in his office, he realised with a chill that hundreds of people have just escaped being burned to death. The homosexual-hating arsonists were never found.

Since the age of three, when he had watched the children from next door playing with his snow, David had felt a strong hatred of injustice. As a small boy he had also demonstrated a tendency to organise. Although politically he had been dormant until the beginning of the gay movement, he found that working to oppose one form of oppression awakened his awareness of injustice to other areas. By 1986, David had an organising role in numerous committees and campaigns.

However, it was not until his friend Mary Robinson asked him to help in her campaign to run for the Seanad when David was alerted to the existence of the Trinity seats, and not until she was successfully elected did he realise that one so young could become a senator. David began to harbour thoughts of running for the Upper House himself. It was to take ten years and six attempts, and would demand incredible strength of character and belief in his own chances of success before David himself was elected a senator.

He first ran in 1977, when he was encouraged by friends such as Brian Murray and Edmund Lynch, and nominated by Dr Noel Browne and Brendan Kennelly. Discrimination against homosexuals was obviously central to his manifesto, but by raising issues such as contraception and abortion - issues which the other candidates avoided - he attempted to persuade the electorate that not only was he prepared to take on controversial subjects, but that he was more than a one-issue runner.

As the campaign had progressed, David had come to believe more and more strongly in his own convictions, and was sure that the voters would be similarly convinced. He received a salutary lesson in reality.

Although he had not hit the bottom of the poll, he received only about 200 votes; despite Trinity's reputation for liberalism, and the support David had received when he had publicly come out, there was obvious resistance to the election of an openly gay man to national office. The prediction of a snobbish, distinguished senior lecturer that 'They'll never elect a queer' seemed to have been proven correct. Nevertheless, some members of Trinity's old establishment such as Professor James McCormick and Morgan Dockrell with his German born wife Suzy, did become steadfast supporters.

Campaigns were expensive and required total commitment from supporters - and candidates - so during David's second attempt at election in 1982, after again working around the clock on his friend's behalf, Edmund Lynch was understandably dismayed when David disappeared to America.

As 1982 was the centenary of James Joyce's birth, David had been pushing for the annual international Joyce Symposium to be held in Dublin. American critics had long cherished Joyce, and felt that the Irish were now making an unfair claim on a writer they had once neglected, despised and censored. David flew to New Mexico in an attempt to avoid a transatlantic Joycean war and returned, mission accomplished; the symposium would take place in Dublin but there would be American and Irish co-publication of the proceedings. Academics, it seemed, were more competitive than politicians.

On his arrival back in Dublin, David encountered in Dame Street an extremely tired and cross Edmund, who informed him he had cancelled the election programme due to the candidate's lack of leadership material.

After a rude but good-humoured response on the part of the candidate, 'You're quite right Edmund. I can't have leadership potential because if I did you'd be sailing over the roof of the Central Bank with my boot print on your backside and a shoelace hanging out of your fanny!', the campaign was back on track. For an entire week, David

stayed up until five o'clock every morning, working in the office at the Hirschfeld Centre, 'with a disco thumping away underneath and half-tight fairies fluttering in and distracting me. But I got everything done.' This phenomenal energy has been seen often.

Nevertheless, David was once more a loser, though heartened by a twofold increase in votes. With the same tenacity, steely determination and disregard of obstacles that had kept his relationship with Ezra going, David was resolved not to give up until he took a seat.

There would be another three disappointments, although each time his vote had risen steadily.

By 1987, his sixth attempt to win a seat, David's interest in the inner city, education, and economic and social issues had convinced the electorate he was more than a one-issue candidate and proven wrong the popular view that gay people were an effete, self-interested, irresponsible little group. He sent out 16,000 letters - all signed - to the electorate, outlining his experience and aims. Nevertheless, he had hesitated before throwing his hat in the ring one more time. His mind was made up for him by the very practical support he received from his friends and colleagues, and one in particular, John McBratney, a Dublin solicitor and barrister. Leaving a campaign meeting early, he put an envelope in David's pocket saying it contained a few suggestions. When David opened it the next day it contained not only a series of very useful suggestions but also a cheque for £500 towards the campaign fund. Another solicitor, Dan Sullivan from the Irish Council for Civil Liberties sent a cheque for £200. This kind of financial help had never materialized before, and indicated a degree of commitment to David's election which was impossible to resist.

'Now people could see I was a full participating member of the community and not narrowmindedly grinding my own axe all the time. If gay people represent 10 per cent of the population, I always believed that if I

concentrated exclusively on gay issues I would be shortchanging the 90 per cent of the population who were not gay. Paradoxically, without any gay content [in my campaign], my election would raise the profile of gay people.'

At the second count, he finally became Senator David Norris, the very first openly gay man to be elected to national public office.

True to form, when David rang to tell Miss FitzPatrick he had been elected and would be on the six o'clock news, she sniffed: 'I suppose that means you'll be late home. And I've never understood why you want to mix with those appalling people.'

David was amused. 'She never considered what they might think about mixing with me.'

Brendan Ryan, who would later become a close friend and was then a senator, had already encountered David when they participated in a debate at UCC during an early campaign. 'Very few people who have met David have not been struck by him at the first meeting,' he says. 'I remember the sheer flamboyance of the man. Later I got to know him well during the abortion referendum; I accused him of showing signs of latent heterosexuality due to his interest in matters of reproduction. He told me he'd gone through a phase like that in adolescence but thankfully had grown out of it!'

Most senators, however, knew David Norris only as, literally, the 'Trinity queer'. They had never heard his sharp, quick wit, they had never met him; they might never in their lives knowingly have met a homosexual.

'On the day he was elected there was absolute horror around Leinster House,' remembers Brendan Ryan. 'People were either deranged with horror at the prospect of a homosexual in the Senate or were involved in a campaign of incredibly smutty jokes, which again was a commentary on their discomfort. It was an enormous shock. I think they were expecting a transvestite to arrive. Or that they were going to be under threat if they found

themselves in the same room as David.'

Shane Ross who, with Mary Robinson, had been returned to the Seanad by the Trinity electorate, also remembers the initial narrowmindedness.

'It's a clubby place and people thought, "Who is this oddity? And he's a poof as well." He wasn't treated as a pariah. They just didn't know how to cope with it.'

David himself felt as if he were facing the first day of term at a new school. He woke up early, feeling prepared and confident, having carefully laid out his clothes - a sober pinstriped suit - the night before. Within an hour he was in a panic, with shaking fingers desperately attempting to sew on a button that had popped off his shirt as he was dressing. Finally, smartly besuited, he slipped on his shoes, snapped one of the laces, and tore around the house searching for a replacement. Fresh out of shoelaces, he was forced to tie his shoe with a tiny knot. He raced to Leinster House, where he was directed to the Dáil, as the Seanad was in the process of being refurbished, and took his seat, excited to be at the very centre of Irish politics.

However, it was inconceivable that David Norris would be overcome by such a sense of occasion.

When the Cathaoirleach, Treas Honan, lamented the fact that Catherine McGuinness had lost her seat, David plunged in.

'Treas is a very decent woman, but she didn't balance her statement by saying how nice it was to see David Norris in her place. So I made the point that it was very nice to see me.'

He began enjoying himself, more so when Treas Honan stood up to be formally elected and John A Murphy muttered in Irish, 'I'm not going to vote for that woman, she hasn't got a word of Irish.' 'Of course Treas took the cue beautifully and nodded to take his compliment on board, clearly illustrating she didn't have any Irish. I found it a good illustration of the value of a knowledge of the language.'

Later David spoke on the business of the day, the Single European Act; he had secured possession of the judgements in a case crucial to the understanding of the subject, and so was able to make a highly informed speech based on a brief possessed by nobody else in the House. Finally, he put in an item on the Adjournment, a facility that then existed for a member to raise an issue of direct importance at the conclusion of business. It surprised most members as very few new senators knew of its existence.

By the end of his first day, David had spoken on the Order of Business, the substantial matters being discussed and the Adjournment.

'I was determined to make an impact. And I did.'

However, it was to take some time before he would be accepted. 'He stuck out like a sore thumb,' explains Shane Ross. 'People were initially frightened of his homosexuality, and then by the fact that he was obviously so clever, articulate and good on his feet.'

David now had two jobs as well as being involved in the running of the Hirschfeld Centre and a number of committees and campaigns; he was also working on the James Joyce symposium and his one-man shows. A host of invitations (most of which he accepted) thudded on to his doormat each morning, and he was facing an impending court case.

After the Supreme Court ruling, the case of *Norris* v. *The State* was referred to the European Commission on Human Rights. It was a long legal journey but finally the Commission made a ruling on the issue in favour of David Norris. The Fine Gael-Labour coalition government was then given the opportunity of accepting this decision or contesting it before the Court. They rejected the Commission's ruling. The case was referred to the Court in May 1987 and the hearing took place in April 1988.

Although the Irish government maintained that

though the laws on homosexuality were not implemented, they were indeed necessary, and argued that 'the moral fibre of a democratic nation is a matter for its own institutions', on 26 October, the Court held by eight votes to six that the laws contravened Article 8 of the Convention of Human Rights. Law reform would now be a matter for the Oireachtas.

Even though it would take some years before the Bill decriminalising homosexuality was passed, the eventual victory was undoubted, the outcome of one man's extraordinarily courageous battle for justice.

'A lot of people were very supportive, but regardless of who did the research, David was the one who went into court, the case was in his name. It was very brave,' says Edmund Lynch, the only other gay man to have given evidence in court.

Moreover, that act of bravery was not for himself but for every homosexual in Ireland.

'I was delighted for David that at the end of the day it won out. It vindicated his decision to go ahead with the case,' says President Mary Robinson today. 'But it wasn't just personal. He did it to help those who were more vulnerable, who weren't in a position to be as articulate and take it into the public domain.'

At the celebratory surprise party, David was given bottles of wine, whiskey and champagne. He drank most of them himself, went to bed at four o'clock in the morning, then woke at half-past ten with a splitting hangover and the realisation that he was meant to be running in the Dublin marathon. It was the city's millenium and a special certificate would be awarded to all those who completed the race.

'I thought I'd never be able to do it and went back to sleep again. Five minutes later I woke up with a jolt thinking, "I can't wait another thousand years."'

So David jumped out of bed, got himself into his little running shorts, hopped into the car, parked in Merrion Square and walked up to St Stephen's Green for the start

of the race.

'There were masses of people out and a wonderful atmosphere. Of course the crowds had thinned out by the time I got in, five and a quarter hours later, but I finished it. Some people have the idea that gay people are drips, but I did the marathon three times. My technique was very good. I kept a steady jogging pace for twenty-six miles. Some tried to impress the crowd and flashed off and I would pass them three hours later, lying upside down beside a hedge.

'But while people talk of breaking the four-hour barrier and the three-hour barrier, I never broke the five-hour barrier. During my second marathon I was even overtaken by a woman who was seven months' pregnant. To be fair I asked her to pass me out, but the two of us had a nice chat as we wobbled along. I asked her why people have to boil a kettle in films whenever someone is going to have a baby. She said she didn't know but that when she had her first baby it was to make a cup of coffee for her husband who was feeling faint. That was when I said, "Would you mind running a little bit further on, because, to be quite honest, should your waters break, I wouldn't have the slightest idea what to do, and I'm nowhere near a kettle."'

David would train out at Bull Island, jogging up and down the three-mile stretch until he had run for twelve miles. He also joined a gym at Capel Street.

He was accompanied by Tony O'Shea, then secretary of the Hirschfeld, but felt uncomfortable that other members might have suspected incorrectly that they were more than merely friends, or been nervous of any other intentions they might have held.

'One day as we were having a shower, Tony dropped the soap. I knew someone was going to make the joke about not bending down when he picked it up, so before they could, I did. The whole place cracked up and I never had any problem after that because they saw I had a sense of humour and knew what they were thinking.'

It was his unfailing sense of humour, his quick wit and his naturally sunny disposition that endeared David Norris to so many people. As Ezra says, 'David thought our relationship to be more than it was. The reality was grey, but he would think pink. In every area of his life, he would always think pink.'

The Department of Norris Studies

'I see, David, that people refer to you as Doctor Norris. But what have you ever written?'

'Letters to the *Irish Times*.'

The contemptuous comment by one of David's colleagues, and his quick-witted response, summed up both the general feeling at Trinity and his own attitude towards research and further qualifications. After twenty years as a lecturer, David was still teaching on the strength of his BA degree, albeit one that had been awarded distinctions in every paper. Unlike most academics, he had not pursued a master's degree, nor a doctorate; he had neither written papers for publication in academic journals, nor published books based on research. He had simply continued to teach for the sheer pleasure of literature and the joy he had always found in sharing that pleasure with his students. He was using his time instead to work in the 'real' world outside the hallowed walls of Trinity.

At one stage David had intended to follow a postgraduate course in international law at Trinity, but was forced to give up his place at the law school after some of his colleagues objected.

'They wondered how I would be doing my full amount of work if I was also studying. Which I thought was a bit odd because many of them played sports, or drank, or enjoyed other social activities and I would have been using my time to study a subject that would be advantageous. They also objected in case it set a precedent and science lecturers might start wanting to study history of art. I told them I thought literate chemists and scientifically literate artists would be wonderful.'

There was also the fear that he might go on to the Bar and leave the English department entirely. His request was turned down.

However, in 1968 David had actually started a PhD on James Joyce, but had become disillusioned after his sixty pages of material received only the comment 'Indent with double spacing'. David needed direct engagement and supervision, but that was not the Trinity tradition at the time.

When a young man committed suicide after becoming depressed because he had been put under pressure to complete his thesis, David halted work on his own, appalled that a life should be lost for such an insignificant reason. He did not wish to adopt a similar set of values; he was interested in books and in his students, not in climbing up the ladder and becoming a professor at the age of forty. All that had become irrelevant. He had already gone through a baptism of fire in what he considered was the real world. There were other, more real, priorities.

This attitude did not meet with approval, nor did his teaching methods, remembers Michael O'Toole. 'David was not beloved among academics because he consistently refused to engage in research, and he was sometimes quite flippant about it. I remember once he made some very disparaging remarks which didn't really go down a treat at Trinity. And some people also thought he was a bit flip in regard to Joyce, because he made it

fun. They would have said, "Of course, David Norris is a great enthusiast but he hasn't got what Joyce would call the real 'academic stink'." I would say much of their disapproval was generated by their envy of his tremendous powers of communication and the popularity of his lectures.'

This academic conflict, together with David's fame and his trips abroad on behalf of the gay movement and the Joyce symposia and in his role as senator, led to a certain tension in the English department. One lecturer comments with disdain: 'We never saw that much of him. He would come in, the headphones of his Walkman in his ears, then disappear.' He was obviously not one of them.

In fact, David was simply determined to concentrate on the teaching and retain his independence as far as possible, staying clear of the rival groups found in many university departments.

'At one stage, when there were battles going on and the English department split into two, I withdrew. I was at a meeting and at the end I said, "Ladies and gentlemen, you believe yourselves to have split into two, the Department of Early, Medieval and Renaissance English, and the Department of Modern English. In fact you have split into three, because we now have the Department of Norris Studies. And the Department of Norris Studies will not be attending the meetings of the other departments but will maintain friendly relations as long as these are conducted within a certain level of courtesy." And for quite a number of years I didn't attend any meetings at all. I was very much my own person.'

If David was in disagreement with any of his colleagues, he ignored them, standing his ground if he felt threatened but refusing to seek confrontation.

'I didn't see fighting with my colleagues as a priority. After all, I was content, more or less, to remain on the lowest level of the ladder so I wasn't getting in anybody's way. They had trampled over me at the beginning but

once they were up a couple of rungs, I should have been
out of sight anyway, happily stuck at the bottom.'

However, David felt that any accusations of putting
his outside interests before his teaching were wholly
unjustified. 'I never shortchanged a student. If I missed a
lecture I made it up, always.'

Michael O'Toole, voicing the memory of many
students, is entirely in accord. 'I think he regarded every
lecture as a performance and felt it an obligation just as
an actor might. He was always terribly busy, always
frantically rushing around, but he pulled his weight fully.
He was never late, he gave full value. He was immensely
popular among the student body.'

Naturally, some performances were below standard
and some students dissatisfied. At one point David was
teaching the short story and Joyce as part of an Anglo-
Irish literature course (later to become an M.Litt) which
he had initiated with some colleagues, including Brendan
Kennelly. Ill with flu, David missed the first lecture of the
second term. The following week, a member of the class,
representing the mostly American students, stood up and
demanded when he would be making up the lecture
because they wanted their money's worth - what they
had paid, no more and no less.

'I just closed my book and said, "In that case you can
shag off home. It is apparently beyond your
comprehension that because I thought you were
interested in the subject I was giving you an extra series
of lectures, which you are not due, out of my free time.
Now I don't feel at all disposed to do so." And I went
home.'

The students apologised and got more than their
dollar's worth when classes resumed.

David's lectures at Trinity were devoted to twentieth-
century prose fiction, including comic fiction and, of
course, the works of Joyce, for which he devised his own
course. It covered the writer's life and writings, and
consisted of a close reading of the text, including the

examination of the subliminal use of particular linguistic patterns, so that David could justify his own theories.

While his students and the audiences who attended his one-man shows were guided through the works of Joyce by an enthusiastic, entertaining and brilliant expert, David had never lost sight of his dream to popularise the Irish writer and bring the centre of Joycean interest back to Ireland. In 1988 that ambition came to fruition - by way of the campaign to save North Great Georges Street.

Further up the street from David's own home, a row of houses, formerly leased to the Legion of Mary as homes to the needy, had been marked for demolition, since neither the tenants nor the Corporation had carried out any running repairs. David tried desperately to save the houses, devising all kinds of imaginative schemes which he then presented to the Corporation. One idea, to turn the buildings into a hostel for Trinity students, to the benefit of both the street and the university, failed due to the lack of the £40,000 needed to repair the roofs. Eventually David was warned that if he continued to obstruct the process of demolition he would be held legally liable should any masonry fall and cause an injury. The houses were pulled down, and David had to be satisfied with his achievement of ensuring that the facades of the houses were reinstated on the apartments that had been built.

Next to these flats was a house that stood on its own, its neighbouring two properties having already been demolished. David could not bear this house to be similarly razed to the ground; it was the last surviving original eighteenth-century house in its row. Number 35 North Great Georges Street simply had to be saved.

Looking through the lease of the house one day in 1981, he found the name Dennis Maginnis. He had struck gold.

Maginnis was a real figure who, in the form of a dancing master named Maginni, had been one of a collection of colourful eccentrics decorating the margins

of Joyce's *Ulysses*. Believing nobody would take him seriously as a dancing master so long as he had an Irish name, Maginnis had suppressed the S in his name, transmogrifying himself into an Italian, then awarded himself a professorship of deportment and dancing.

David tore round to Dublin Corporation with the threat that if they touched one brick in the building, he would parade on the steps in front of the Eurovision Song Contest and denounce them for their philistinism and for destroying a significant link with Joyce's Dublin. His menaces were met with the quiet advice that he should take the other approach, and make a submission to the cultural committee of the Corporation.

It was not encouraging. David was already known to the cultural committee and would hardly be remembered with affection. With the Sheridan brothers, Peter and Jim he had brought over *Mr X*, a play from the London theatre group Gay Sweatshop. The councillors had found the production quite unpalatable, had withdrawn the producers' grant and tried, unsuccessfully, to close the theatre.

Now David had to face them again. He made his plea and waited for comments.

'One old boy put down his newspaper and said, "Well, I would like to ask Mr Norris, supposing we hand over this magnificent eighteenth-century mansion -" he apparently hadn't noticed the roof had collapsed and there wasn't a pane of glass in the place - "what guarantee can he give to the Corporation of Dublin that it would not be used for his other *fringe* activities?" He put such a wealth of pointing into the word that I knew exactly what he meant, but was able to convince him that I could contain my grosser appetites within the confines of my house across the road and leave number 35 free to be polluted exclusively by the shade of James Joyce - about whom he wasn't a bit enthusiastic either.'

In November 1990 the lease was finally handed over to a limited company newly formed to renovate the

house and establish a James Joyce Cultural Centre. The chairman of the company was David Norris, who had happily taken on yet another commitment. Now all that was needed was money.

But almost immediately after, as one building was saved, another was lost. The Hirschfeld Centre went up in flames.

David was woken in the early hours of the morning and called to Fownes Street where he saw the building ablaze. Relieved that nobody had been injured and the archives were safe, he rather relished the dramatic spectacle of the flames curling up into the sky.

It was unclear whether the fire, which had started in the lobby, had been caused by a lighted cigarette, carelessly thrown into a wastepaper basket, or whether those responsible for the attempted bombing a few years before had finally achieved their aim.

Later, in the clear light of day, David surveyed the burnt-out building and reflected on the loss. In a small city like Dublin with little diversity for the gay community, any new venture would attract the whole Hirschfeld crowd. 'Then we would be staring bankruptcy in the face. We were in one of those hollows at the time, so I thought at least the insurance money would stave off the crash.' Typically, he was looking at devastation in a positive light.

'It was a huge shock,' remembers Bernard Keogh, who had been an early member, running the Centre's library. 'The whole drive to open it was due to David's energy and vision. Now after running successfully for years that vision was snuffed out. That was the saddest thing about it.'

The loss of the Hirschfeld Centre was felt deeply, not just by David and his co-directors but by the entire gay community, who no longer had a lifeline. The removal of the centre's facilities was an additional setback for the growing number of gay men who were worried or

affected by AIDS. The Hirschfeld Centre had responded to the AIDS crisis by participating in the work of Gay Health Action (GHA), founded in 1985. For nearly two years the GHA was the only organisation providing information and advice, with posters, lectures, leaflets, a telephone helpline service and an HIV-positive counselling group. The government praised their efforts; it also refused funding.

The gay community in Ireland, as elsewhere in the world, was badly hit by the virus; initial hysterical, anti-gay media coverage deepened any existing hatred towards homosexuality and lost the gay community some of the support of those who had become sensitive and well disposed towards gay issues. The virus also claimed a large number of lives - and continues to do so.

'Several groups of people who I knew, lovely, warm, generous-hearted people, are dropping off now like flies,' says David sadly. 'I was lucky in the sense that when people were celebrating their sexuality and perhaps took risks, not realising to what they might be exposing themselves, I was more fastidious. I was also very heavily occupied by the political side of the movement. And I felt a certain inhibition in getting involved with people I met through it. I felt they would have seen me as just another manipulative, exploitative person. It would destroy their confidence in themselves and in the gay movement. I couldn't use people in that way.

'And many may have seen me as some kind of cult figure and it would have been the easiest thing in the world to get the knickers off them. But they might have had some idea of me they had manufactured themselves and then been completely disillusioned, and I wouldn't have known if it was me they were interested in or the kind of figurehead they had read about in the paper. That was the lovely thing about Ezra. He didn't see David Norris the Trinity lecturer, or the performer of one-man shows. He loved me for what I was.'

David has the greatest respect for the way in which

Ezra cared for his friend Rafi, the first AIDS patient in Israel.

'When Ezra used to come in after work he would just walk out of his clothes, dropping shoes, dungarees, shirt and pants all over the place on his way to the shower, making a terrible mess. But he hates dirt. Yet for two months he looked after Rafi, changing his nappies, because he had everything - the dysentery, pneumocystis, kaposi's sarcoma ... he went blind, he went bald. I thought it was simply terrific of Ezra.'

Ezra felt it was his duty to help a friend in need at a time when little was known about the illness and when few people, including professionals, wished to go near AIDS patients. It was also a practical way of demonstrating his political beliefs. Similarly, he now aids an old refugee Palestinian couple whose children have had to leave the country to find work abroad. He visits them, does their shopping and has built a solar heating system to provide hot water for their house.

'That is my duty now. I feel like giving something to society, not just having sex and food, and I feel guilty and kind of responsible to them. They are refugees because we Israelis are here.'

Since Ezra had fallen in love with Isaac, David's faith had continued to be an enormous comfort. It also turned his jealousy into generosity as he prayed for the happiness of the two men so very far away.

'I don't think you can resent the wellbeing and happiness of two good people,' he says. 'The fact that Isaac was so kind and considerate to me was a very positive factor and it couldn't have been easy for him to be suddenly made aware of my existence. And I couldn't stand, totally, in the way of Ezra finding happiness.'

Nevertheless, nor was David able, totally, to let go of his relationship with Ezra. The Friday-night phone calls continued, as did the visits to Jerusalem. Ezra was just as keen to maintain their liaison; the love between them was clearly too deep to allow a complete separation.

But it was distressing for Isaac. 'When David phoned he would fill us with details about his life, so it meant you were aware of his daily existence, what he was doing every minute, even how the cat and goldfish were. If I was in the mood to have a conversation with him it was OK, sometimes he was very funny. But if I'd had a fight with Ezra and then heard him laughing on the phone with David it would upset me. But I opened my house to David. I made him welcome. I didn't think it would hurt. But it was a mistake, both for me and for him. David used to come to Jerusalem every year, and every year, for me, it was hell.

'David knew how to catch Ezra's attention deliberately. He wanted exclusivity. He wanted to be the centre of attention. Ezra couldn't even run his social life when David was around, because he would get jealous. It was difficult to have him as a guest because he was a child who wanted attention all the time. You needed to spend a lot of energy to please him, you hardly had time for yourself. Sometimes I couldn't tolerate his behaviour, when he behaved like an infant, joking with Ezra about farting, never serious. And Ezra always, always accepted David's point of view and both of them were against me.

'It was a terrible strain for me because my relationship with Ezra was often on a shaky level, and when it was good, I couldn't express my feelings. Once we all went for a day to Jaffa, a pretty little port in Tel Aviv. We thought we would walk in the old streets, swim in the sea, and afterwards have a nice meal in a restaurant. I felt very happy, I wanted to hug Ezra, but I couldn't because David was there.

'I used to say to myself, it's a delicate situation, he's only here for a month, try to restrain yourself, but it was very difficult. It was also difficult for David. He must have really suffered. I used to buy flowers for me and Ezra for Friday night and he told me he would see me in the street, my arms full of flowers. To see that domesticity must have hurt. And he would have to sleep

in the next room, with the man he desired sharing my bed.

'It would be me who would try to keep Ezra quiet if we had sex, and Ezra said no, it didn't matter. I felt sorry for David.'

Rocking the Boat

The initial horror felt around Leinster House by David Norris's election soon dissipated as individual senators came to know him personally.

'The staff certainly warmed to him very quickly because he was always so nice to people and then the elected members realised what a likeable man he was,' explains Brendan Ryan. 'Even those who were publicly hostile to gay-rights issues would get on with him on a personal level.'

On a political level, David's articulate and passionate speeches soon attracted attention. 'When he spoke, especially on issues very close to him like the suffering of people with AIDS and the discrimination against them, I think the whole of Leinster House took him very seriously,' says Brendan Ryan.

It also became clear very quickly that Senator David Norris was unafraid of speaking his mind, regardless of the consequences.

With yet another increase in his public profile, his hate mail, already contained in a huge file, grew accordingly. Enda Dowling, his secretary until 1995, felt for David.

'Letters would arrive, really nasty, horrible letters. He

seemed to read them and laugh, but I would always think that you can't receive letters like that and not be affected. He told me, "If you ever think I'm getting too full of myself, put them on my desk.'

Joe O'Toole shared an office in the Oireachtas with David, and the letters that arrived informed his own views about coming out. 'I know it's a politically incorrect remark but many times I would be sorry for David. It is difficult to be a public gay in Ireland. The sort of hate mail, and even quite mild utterances, that it generated made me think that gay people shouldn't feel a need to come out. I would say he suffered.'

David himself shrugs it off; as Enda says, he gives the impression of amusement. 'I used to get messages on my answering machine and I remember one from a woman who left a string of abuse about me in exceedingly foul language and then followed it by a po-faced remark about the example I was setting her children. And one man said he would like to come round and stick a submachine gun up my arse and pull the trigger. Then he thought for a moment and said, "Only you might enjoy it." I thought they were hysterically funny.'

Abuse was not limited to letters and messages. David was often personally confronted in the street. 'One anti-abortionist once felt she was entitled to abuse me on the public footpath. She said I was a bumboy and responsible for the death of babies, all that sort of stuff,' he remembers. 'And these are supposed to be the acme of Christian values and family virtues. I think there are a lot of contradictions there. This kind of extreme view is not a sign of strength but of a lot of inner confusion and weakness. I actually feel quite sorry for people like that, because I think their own beliefs are insecure. They've got to project them and try to make everybody else believe the same because they don't really believe it themselves.

'There was a time when I would be rather shaken if somebody who I respected intellectually, approved of morally and liked personally turned out to be an atheist

but now it doesn't bother me at all because my own beliefs are much more secure. And if you're the only person in the world who believes them, so what?

'I had the great advantage of having all my beliefs challenged from quite an early age, but these people haven't. And I think it's the same with the extreme Orthodox Jews in Mea Shearim in Jerusalem, the mullahs in Iran and the fundamental Protestants in America. I think a lot of these people are daylight atheists and actually terrified God doesn't exist, but by forcing others to believe in the same kind of God it builds up God's strength. But I don't think it works like that, and God should be old enough and wise enough to look after herself, himself, itself or whoever it is, without needing someone like the Ayatollah Khomeini for assistance. Surely if God is an omnipotent, omnipresent being, he, she or it should be able to withstand a few laughs or sniggers.

'It tells me that these people believe in their own control and power, and their own inadequacy which they refuse to recognise.'

It was this outspokenness that earned David a death threat from the IRA. One day he came in to find his secretary at Trinity in floods of tears. A letter had just arrived warning him that if he didn't leave the country by the end of the year he would be executed.

True to form, David immediately trooped round to Sinn Féin's headquarters in Parnell Square and showed the letter to those present. 'One of them, a very well-known IRA member, said he had no knowledge of it at all and asked me if I had written letters to the newspapers. I said, "Yes, I write frequently about inner-city restoration, homosexuality and much more, but I haven't come for your permission to write letters to the papers. I've just come to say would you mind not sending any more of this material because my secretary finds it deeply disturbing. If you must execute me, why don't you telephone and make an appointment, because

I'm just round the corner in North Great Georges Street?"
But the police advised me to take it very seriously, to go
home by a different route every day. I said, "I work in
Trinity, I can go over Butt Bridge or O'Connell Bridge,
there's not much of a choice and it's not going to confuse
anybody."

'So I went and leaked it to the papers.'

But a death threat did not curb David's need to speak
his mind. He would picket the offices of the Sinn Féin,
quoting from Sean O'Casey's *The Shadow of a Gunman*:

> I'm a nationalist meself, right enough; I believe in
> the freedom of Ireland, an' that England has no
> right to be here, but I draw the line when I hear
> the gunmen blowin' about dyin' for the people,
> when it's the people that are dyin' for the
> gunmen!

Later he was one of the protestors aboard a Peace Train
that travelled from Dublin to Belfast. It was, he felt, an act
that did not involve politics, discrimination or religion,
but simply highlighted a practical issue - that the railway
link between Ireland and the North should remain open
for the benefit of ordinary families. The atmosphere on
the train, which held politicians, public figures and
members of the public, was jolly as they were seen off by
the Mayor of Dublin and met by the Mayor of Belfast.
The journey back, however, was more fraught, for a
member of the IRA purportedly told the police that there
was a bomb on the line. The train immediately ground to
a halt, stopped in a siding near Portadown, and the
passengers were requested to leave the carriages
immediately and board buses that would take them back
to Dublin.

When David saw that Jack McQuillan, a colleague of
his friend Noel Browne, was still in his seat, he wondered
if perhaps Jack were unwell, and asked him if he were all
right.

'Of course I'm all right,' Jack replied.

'Then you'd better hurry or you'll miss the bus,' advised David.

'I certainly am going to miss the bus,' said Jack. 'I came on a peace train, I'm going back on a peace train, and I'm not going to be thrown off by the IRA.'

David agreed with his sentiment, and as word spread, others did too. About ninety passengers refused to leave the train. Before long, news reporters and camera crews from RTE, the BBC and CNN had arrived. In propaganda terms, it was a dramatic victory for the peace protestors.

They stayed on the train overnight as sympathisers brought coffee and sandwiches, and returned to Dublin the next morning - on the peace train, to David's great delight and excitement, for with the escort of two helicopters, he felt as if he were in a movie.

As Senator David Norris, he would continue to take an active part in any process that could lead to peace. He spoke regularly in the Seanad about Northern Ireland; joined the New Consensus group, with its aim of reconciling the political identities north and south while struggling against violence; was a member of the coordinating committee of the Forum for Peace and Reconciliation; and consistently called for talks with the IRA, while believing also that politicians in the south should make an effort to understand the Unionist point of view and ensure that any new Ireland was one in which people from a Unionist background would feel comfortable.

It is perhaps even more courageous of him to be so outspoken considering his very real fear. While laughing off hate mail and death threats, David admits that, at times, he felt very afraid.

The event that possibly had triggered the death threat took place at a meeting of the Trinity Philosophical Society. An IRA chief-of-staff had been invited to appear. 'In the usual liberal tradition all the speakers are welcomed and I got fed up with this chorus of approval. Then the IRA man started a very strong speech about 800

brutal years of bloody occupation by the British jackboot and how Irish writers and artists had always supported the arms struggle, and I stopped him. I said, "As far as I'm concerned, it is of course interesting to hear you and you are entitled to free speech, but don't run away with the idea that you are universally welcomed because I don't welcome you at all. Apart from anything else, you're seriously misinformed about the attitude of Irish artists. I suggest you read O'Flaherty's *The Informer* and the biography of Brendan Behan, where he is quoted as saying if his plays show one thing, they should show that no ideal was worth the shedding of one drop of human blood." And I ended up quoting Seamus Shields.

'On the way out two little squirts in anoraks got themselves on each side of me and said: "We know who you are, we know where you fucking live. You better get yourself a bullet-proof fucking vest, Mr Norris." So I said with great aplomb, "Considering the fact that you couldn't hit Strabane police station with a milk churn full of dynamite from a helicopter I'm not too worried about what you could do to me with a bullet." But it wasn't true. I was worried. I took to my heels and fled.'

David had returned to Israel a number of times since that uneasy meeting in The King David Hotel, and he and Isaac had become very fond of one another, if still resentful about the other's hold on Ezra. But by 1989 it had become obvious to David that Ezra and Isaac's relationship was in trouble. Although he still cherished the hope that one day he might get back with Ezra himself, his letters to them were generously supportive and compassionate:

Dearest Isaac ...

It is a pity that you and Ezra are having difficulties. I do not want to take sides in this issue or lose the friendship of either you or Ezra ... You know I love Ezra and have for many years.

But you also know that I love you both, as
individuals and separately for yourselves as well
as as a couple. It pains me that either of you
should be so unhappy and if there is anything I
can do you know I am here as a friend. It would
be pointless and impertinent for me to intrude in
your life or to interfere between you and Ezra but
please believe me that I am always here for you.

Love, David.

In the meantime, he concentrated on re-election to the
Seanad. Again David was nominated by Dr Noel
Browne, former Minister for Health, who stated that for
many years he had 'marvelled' at Mr Norris's
'extraordinary courage in making himself a sacrificial
lamb' to help homosexuals, and how privileged he felt to
have worked with him.

His seconder was Dean Victor Griffin of St Patrick's
Cathedral, who said he had always been impressed by
David's great courage and integrity and was especially
appreciative of the work he had done on behalf of the
disabled both inside and outside the Seanad. 'The
forgotten people in our society need people like David
Norris in the Senate,' he said.

Again David's manifesto contained an impressive list
of supporters, his educational background, academic
distinctions and political interests. But to these he could
now add his achievements as a senator. He had attended
the House regularly, spoken consistently and with effect
in every major debate, amended government legislation
and placed his own legislative proposals on the order
paper of the House. He had also been instrumental in
special debates in numerous areas, including pension
rights for the visually impaired, and had been appointed
Secretary of the Foreign Affairs Committee of both
Houses of the Oireachtas and to the Joint Oireachtas
Committee on Women's Rights.

If this was not sufficient to convince voters of his

effectiveness, there were the issues he promised to raise - the environment, inner-city revitalisation, health, AIDS, hospital closures, unemployment, education, human rights and the North.

Clearly David Norris was a conscientious and productive representative in the Seanad, and he was perceived by the electorate as such. He was returned to the Seanad on the first count with a massive 2,420 votes, just twenty-three votes fewer than those received by his colleague, Shane Ross.

Six months later, in February 1990, he was fighting to save his seat.

Once more it was his outspokenness and his strong sense of justice that drove him to take an action that was, courageous or, some might say in this case, downright foolhardy.

David had alleged that there had been a partisan political involvement of the Cathaoirleach, Sean Doherty, something which, if proven, would have been a serious abuse of his position. David's comments went unnoticed for a few weeks and then the storm broke. He was invited to withdraw his remarks.

'I think some of the cute boys in Fianna Fáil thought it would be a good way to teach me a lesson and bloody my nose. I had been very vocal, fighting very passionately and,' he admits, 'I suppose rattling people a bit by things I had said. Perhaps they felt I was a little pup who had bounced into the Senate, behaving like a one-man government and not observing decorum and etiquette.'

David refused to withdraw his allegation, feeling he could substantiate it, and was called before the Committee on Procedural Privileges to be forced to recant. The chair of the committee was Sean Doherty.

'That seemed to me to be wrong. Also, there was a built-in government majority on this so they would vote as lobby fodder against me. I said I wouldn't take part in

the proceedings unless Mr Doherty was removed as chair, and I asked for the right to be legally represented.'

When his requests were refused, David swung into action. 'I said they had violated my natural and constitutional rights and if they proceeded against me and threw me out of the Seanad I would get straight into a taxi, collect Mary Robinson on the way to the High Court and take out an injunction against them. And I did.'

Once again Mary Robinson found herself representing a client in an interesting and innovative case; never before had a court interfered in the procedures of parliament. 'There was a sense that you cannot sue the Cathaoirleach and the Senate,' she says, 'but we got leave to apply for a judicial review.'

It was a difficult case: with the back-up of only a few independent senators, David had almost single-handedly taken on the entire Seanad. 'I had very good support from Joe O'Toole, and also Shane Ross, who was simply marvellous. An attempt was made, which actually failed, to impeach Mr Doherty and remove him from the position of Cathaoirlach. I was precluded from taking a central role in the debate on Mr Doherty because of the legal implications, but Shane was the first speaker and he eyeballed him, telling him he was unfit for the office. Now that required a great deal of moral courage because Shane was friendly with Sean Doherty on a personal level.'

When the case was heard, the court ordered that David Norris should be reinstated and he was ceremonially reintroduced into the Seanad.

'It left me feeling a bit irritated because there was a Bill going through dealing with building regulations on which I had been extensively briefed. But I had been fired out of the Senate in the middle of it and didn't make my contribution. I could have challenged the passage of the Bill but was advised, and felt myself, that if I went that far and tried to overturn the legislation, forcing it back

through the Houses, there would be such antagonism [that] my amendments would not be regarded favourably and it would also look as if I was really turning the knife in the wound.'

David let the matter drop and contented himself with his achievement. Politics is a tough business, and he had demonstrated that he possessed parliamentary skill and could not be pushed around or easily silenced. It was now quite clear that David Norris was prepared to take on controversial issues and fight them right through to the bitter end.

He had shown great courage, but, according to Shane Ross, perhaps not the greatest political wisdom. 'David went way out on a limb and it was brilliant, a great victory, but he had taken an enormous risk,' he comments. 'He could have lost and been publicly proved to be wrong. He would have become a partially discredited politician. It would have looked intemperate and ill considered. Other politicians would never have taken the chance. They would have kept quiet, done nothing. But David is emotional and passionate and just follows his instincts regardless of the political consequences. I would say he is politically reckless, totally. But,' Ross continues, 'funnily enough his stock soars, because people recognise this. It doesn't do him any damage with the Trinity electorate. Quite the opposite.'

It seemed that any issue involving David Norris received a huge amount of publicity, far more than that received by any of his colleagues, some of whom rather envied the attention he was able to attract.

'I would defend him on that,' says Joe O'Toole. 'He always got coverage because he's interesting and he can communicate verbally very, very effectively.'

There was no doubt that David Norris had become one of the finest and funniest speakers in the Seanad, the only senator worth listening to according to some. 'His amazing use of language, his throwaway lines, his

appropriate quotations from Joyce - they became part of the stock of the Senate,' says Brendan Ryan. 'He's so witty, sharp and original, none of us can live with him. His famous dismissal of the Archbishop of Dublin knowing a lot about angels but very little about fairies - no one else could have said it because we would have been accused of using politically incorrect language. None of us could even have come up with it.'

David was not only quick-witted and articulate; he had mastered the complicated technical language of legislation. Driven by his sense of justice and compassion, and determinedly unaligned to any political party, he had also endeavoured to use his freedom as an independent senator to maximum effect. In the view of some, the Seanad was little more than a retirement home for redundant politicians, partially due to the voting system - most senators were captives of political parties, voted into office by panels and nominating bodies. David felt that those occupying university seats were in a stronger position; they had fought real elections and as independents should really be able to make their presence felt in terms of legislation.

In May 1990, two months after the Sean Doherty affair, Senator David Norris attempted to do just that. Again he managed to rock the boat, but this time he shook the government too.

The Seanad had been established in 1922 and had been invested with quite considerable power over government; it could spend money and upend government legislation. When Eamonn de Valera came into power in the 1930s he had control of the Dáil but not the Seanad; the two Houses were constantly in conflict. In 1936 he therefore abolished the Seanad, and the following year introduced the 1937 Constitution, reconstituting the Upper House along 'corporate lines', with various panels supposed to represent different interest groups. He also loaded the Seanad mathematically so that the government could never be

defeated in the Upper House; because of the method of election, the electorate would to a large extent reflect the political strength of the different parties. De Valera added a provision whereby the Taoiseach could directly nominate eleven people to the Seanad. With this mathematical loading, it was impossible for the Upper House to overturn government legislation or to cause a defeat of the government.

David Norris regarded this as an intellectual challenge. Eventually he worked out how the government could be defeated and waited for the opportunity to arise.

Sitting in his office in Kildare House one day, listening to the proceedings on the television monitor, he heard a Labour colleague, Joe Costello, introducing a sexual-orientation clause into the Larceny Bill, proposing an amendment to delete a reference to 'the abominable crime of buggery'.

Although David had pioneered the introduction of sexual-orientation clauses in order to extend to travellers and gay men any protection given to minorities by legislation, and had managed to get such clauses into the Incitement Bill and the Video Bill, he became alarmed. 'It was quite clear to me that because of the involved way the law works and is framed, the net impact of his amendment would in fact be negative for gay people and could expose them to possible blackmail. So I decided to charge across to Leinster House and get in on the act.'

Breathless, David arrived in the chamber in time to hear the Cathaoirleach announce that the House would now take a vote. There were just four senators present, none of whom was a member of Fianna Fáil; even the chair was temporarily occupied by a member of Fine Gael, who put the amendment to the House by means of a voice vote.

Although David disagreed with the amendment, he joined the other senators and said, '*Tá*'.

It was clever tactical voting. If the Bill was passed, it

154

would protect anyone who blackmailed gay people, thereby making the legislation highly embarrassing to the government. The automatic presumption in favour of the government from the Chair resulted in the Cathaoirleach declaring the Opposition's amendment defeated.

Senator Norris immediately stood up.

'Excuse me, Cathaoirleach, but you did not call a roll vote, you called a voice vote, and you asked for those in favour to say "*Tá*", which the three of us here did. You did not ask the people who were opposed to say "*Níl*", and there may have been a very good reason for that because there is nobody on the government benches. So by no stretch of the imagination can you assume you heard anybody opposing the Amendment, so it was unopposed, so it was passed.'

The Minister of Justice, Ray Burke, tried to smooth out the situation, but David Norris would not back down. 'I said I would not move until there was a decision,' he says. 'They sent out for the law books, all hell broke loose, and white-faced and trembling, the Cathaoirleach had to accept the government had been defeated. And because the Fianna Fáil members were in such hysterics, all arguing and blaming each other out in the lobby, they lost the two roll-call votes as well! So the government was defeated three times in the same day, for the first time in fifty-three years, and Mr Haughey, then Taoiseach, fired the entire front bench.'

The defeat of the government and the ensuing political uproar had been enjoyable but David found other satisfaction in the affair. 'It showed that the government could be challenged, and by an Independent, but also that the Seanad was alive, an interesting and exciting place, and that people could speak out on issues of principle and have an impact.'

And, of course, the incident had demonstrated once more that David had developed the necessary skills to become an able parliamentary tactician.

After all the frenzied political activity during the year - and the already heavy workload imposed by his job, travels and commitments - David should have been exhausted. However, his energy levels were higher than ever, and his spirits soaring. Although troubled by Ezra and Isaac's relationship, he was elated to hear they were coming over for Christmas.

Dearest Isaac ...

I am concerned that you seemed to suggest the last time we spoke that things between Ezra and you were a little difficult. Believe me, I love you both and I want you to be happy together ... I think you will go a long way before you find another Ezra and I think the same is true for him too ... I'm looking forward to your visit and to giving you a really good Irish Christmas ...

Love, David.

He was true to his word. He hired a horse-drawn carriage to take Ezra and Isaac to the theatre, stuffed their huge Christmas stockings with presents, lit great fires in the drawing room, provided a splendid Christmas meal, and, after they had sat up late watching Chinese horror movies, regaled his guests with stories of the house ghost.

'I once saw this man coming down the stairs and said good evening, wondering who he was and what he was doing in the house. I asked Mrs McGurk, my sitting tenant, if she had let anybody in, and described the man I had passed on the stairs. She said, "Oh, that's Mr Brennan. He was an IRA man who lived on the top floor and drank himself to death about twenty years ago." It didn't bother me in the slightest, but after Ezra heard this and was dying for a pee, he was too afraid to go upstairs. When he eventually did, Isaac and I waited on each side

of the door and when he came out made ghost noises. Poor Ezra thought he was being attacked by Mr Brennan. We had great fun that Christmas.'

Isaac remembers it as a 'beautiful' time. 'It can't have been easy for David because Ezra and I were still a couple, so he was very brave, and he also went out of his way to please us. He was more than perfect actually.'

CHAPTER ELEVEN

Foreign Affairs

For most of his life, Tom Hyland had worked as a Dublin bus driver, although his most enjoyable job had been delivering flowers; he loved seeing the delight in people's faces when he handed them a bouquet. In 1991 he was unemployed, having taken a job as a truck driver and subsequently been made redundant. One evening, at his home in Ballyfermot, a deprived working-class area of Dublin, he was playing dominoes with some neighbours. On television a documentary was being shown. Absorbed, the group put down their dominoes and at the end of the hour-long programme could not resume their game.

'There was a level of anger in the room that I'd never encountered in my life,' remembers Tom, a gentle, affable man. He had learned from the documentary that in East Timor, a small Indonesian island, atrocities had been carried out by the Indonesians on an alarming scale for the past twenty years; a third of the population had been massacred and six journalists murdered after attempting to publicise the situation. Tom and his neighbours had watched as a group of Indonesian soldiers, caught on camera, killed 250 young people in a cemetery. 'I'm not

ashamed to say that I cried,' he says. 'I cried about what had happened to these people and when I went to bed that night I just could not sleep.'

The following day Tom found that his neighbours, too, had been just as upset. One suggested that, instead of talking about their reaction, they should take action. With no resources and no experience of activism, they decided to set up a campaign. 'We were a little naive,' smiles Tom, 'but sometimes that's a wonderful thing. We just went into town and began knocking on doors asking people if they would give us typewriters and paper so we could begin our campaign.'

One man was obviously touched. Brian Anderson, who worked in an office in Merrion Square, gave them a typewriter. Back at Tom's home, they moved all the front-room furniture to one side, set the typewriter on a little table and the campaign was born.

Letters were sent out to anyone they thought might help, including politicians, and one of the first to respond was David Norris. 'At the formal launch of the campaign we held a vigil at the American, British and Australian embassies, because they all supplied weapons to Indonesia. David was one of the speakers and there was no political double-speak or half-measures; he just said that what was happening in East Timor was morally unjustifiable and we should all be ashamed. I remember his words. It gave us a great uplift to continue because we were going through a dreadful process at the time.'

Tom and his fellow campaigners had begun to read the available research on the violations of human rights in East Timor. 'I would read a bit, and just when I thought I'd got to the worst, I'd turn the page and there would be more - the rape of women, the killing of women and children, the torture of young men. I'd have to literally walk away from it by taking the dogs out. It was very difficult because we'd had no training in this and we all took it extremely personally. There was also a great deal of coming to terms with what politicians say,

and what they actually do.'

However, Tom says he found in David Norris a consistency of principle, a refusal to hide behind clichés for political reasons, and a bravery in speaking out persistently. 'We knew he was involved in many other groups, so we didn't expect much to begin with, but suddenly he started mentioning East Timor whenever he was giving interviews. I remember one night watching *Questions and Answers* and the panel was discussing atrocities by the IRA and UVF. David said, "Let's not forget the British government. Their hands are dripping with the blood of innocent people too," and he gave East Timor as an example. He wrote about it in newspaper articles, and when we checked the records of the Dáil we'd find a question on East Timor. It was absolutely wonderfully uplifting, and he hasn't stopped since.'

David had shown a commitment to foreign affairs some years previously when he had embarrassed the government by forming his own Foreign Affairs Committee which had Michael D Higgins as chairman and members from every political party. When the government subsequently set up their own committee, David was one of only five senators selected as a member. He was also appointed to the committee's Bureau, which sets its agenda. It was a powerful position for him to have.

David spoke passionately in the Seanad, took part in vigils, joined picket lines, wrote to foreign ambassadors, and became trustee of a fund to help victims of torture.

As Joe O'Toole points out, David's interest in foreign affairs was broad but often focused on specific concerns. One such case was his commitment in honouring the work of Raoul Wallenberg, a Swedish industrialist and diplomat who had saved the lives of thousands of Hungarian Jews in World War II. When David first read of Wallenberg in a book called *Why Six Million Died*, by American author Mitchell Moore, he was moved to tears. With extraordinary courage, Wallenberg had issued

Swedish passports to Jews, thrusting papers into the hands of anyone he could reach: to people in the cattle trucks stuck on railway sidings on their way to Auschwitz; and to those on foot, on 'death marches'.

'There are utterly shameful events in Christianity, yet here was someone who really was a righteous Gentile. There were only a couple of paragraphs about him in the book but I thought it was a beautiful story which showed there was decency in the human spirit.'

Some years later, after attending a conference in Stockholm, David found himself at Copenhagen airport with some time to kill while awaiting his flight home to Dublin. He walked around, drank a cup of coffee, looked out of the window, went to the lavatory, walked around some more and discovered a bookstall that had a few books in English. One, *Righteous Gentile* by John Biermann, caught his attention. David had been very moved by his visit to Yad Vashem, Jerusalem's Holocaust museum and the national memorial to the six million Jews who perished in Nazi-occupied Europe. He had seen its Avenue of the Righteous Gentiles, a tribute to those who had helped to save Jewish lives. He bought the book and found himself involved in another search for justice. Now he was unable to accept the simple references to Wallenberg's death in 1945 while in Russian hands.

'I felt,' he says, 'people accepted he was dead because it was convenient, it tidied things up. But no documentary or genetic evidence had ever been produced of his death. I was a hundred per cent certain that Wallenberg was alive in the sixties, seventies, into the eighties, and could even be alive today. I felt we had a moral responsibility to continue to assert that he is alive until proved to be dead, however embarrassing for the Russians.'

David's belief that Wallenberg survived is not so fanciful. Over the years there have been countless reports, some highly credible, of sightings of the Swede

in prisons, in mental homes and in labour camps. However, the Swedish government's intermittent diplomatic efforts to solve the mystery were ineffectual and undetermined, often out of deference to the Soviet Union. For years it was left to Wallenberg's family and close associates - and to interested overseas supporters such as David Norris - to keep the search alive.

His concerns would often take him abroad, and there, as at home, he would show his usual fearlessness in speaking his mind. In Canberra, in the Australian parliament building itself, he caused a scandal with his scathing, trenchant criticism of the Australian foreign policy on East Timor. In Delhi, at a conference of the Interparlimentary Union in 1991, the shock was almost palpable when David had finished his speech about the AIDS crisis. Other members of the Irish delegation congratulated him, yet wondered if perhaps he should have mentioned that he was gay.

Two days later David had a second opportunity to speak. He acknowledged to the assembled politicians that he may have embarrassed them earlier and went on to say how pleased he was, because they had an awful lot to be embarrassed about.

> If one applies the Kinsey, Pomeroy and Martin statistics of 1949 you will find that 10 per cent of any large group is homosexual. That means that unless this audience is statistically aberrant, 10 per cent of you are gay. I understand your silence, because in a majority of those countries represented here people such as myself would be liable to legal prosecution and even murder, but I feel an obligation to speak out on behalf of those who cannot speak out for themselves ... I am a simple man and have never understood the elevation of human reproductive biology on to an absolute moral plane. By what convoluted logic the introduction of the penis into the vagina confers superior moral status upon those

engaging in such acts defeats me. But I suppose in a world where dowry deaths and female circumcision are still prevalent, I should not be surprised.

'These things had to be said, particularly in India where they were covering over the whole AIDS epidemic in a most disgraceful way,' he says. 'Several people came to me privately afterwards and thanked me for saying it. That has happened again and again, in small, national and international circles; people have come up to me afterwards and said, "Thank God, at last somebody has spoken out." That, to my mind, is the great value of being independent. I can say things others don't have the freedom to say or are afraid to say or cannot say. I have to, out of principle. There is a moral obligation. Cynical operators are getting away with scandalous policies because people are too polite to challenge them, thinking, "We're part of an official delegation, we've been taken to a wonderful palace, we've been given an official meal, welcomed by the President, we can't really be rude." Why not? What can they do to you? They can't put you in prison.

'Sometimes I'm nervous of it. When I went to Paris for the recent COSSAC meeting everything was so splendid, so wonderful and everyone else was being so polite. I felt: here is Alain Juppé, then foreign Minister and now Prime Minister of France, and I'm about to accuse his government of moral imbecility. But, I thought to myself, what about the people who are actually being tortured and murdered in East Timor? And like Britain, because of jobs in the armaments industry, the French are prepared to turn a blind eye. Whatever rudeness is involved, it's nothing compared to the suffering that these people, who have no voice, are going through.'

Naturally it rattled David's sense of justice when such trips were seen as political junkets. However, not all his travels were dedicated to political purposes. With invitations from all round the world to perform his one-

man show, David was tempted on a number of occasions to take them up, particularly if he could combine his performances with a meeting with Ezra.

So, in 1982, he accepted an invitation to perform in Beirut. Many other representatives of the Joycean international community had sensibly decided to avoid unnecessary travel to a country at war, but David enjoyed the excitement of the drive from the airport in the ambassador's car, flanked by a motorcycle escort, past lines of tanks. He was also rather pleased with the beautifully timed sound effects. As he was talking about the way Joyce reflected his ambiguous feelings towards his father in *Finnegan's Wake* - 'one moment he was Tarabooming great Blunderguns ...' - a bomb went off and every light went out.

He left Beirut in an airplane that took off almost vertically to avoid a barrage of gunfire. David flew to Amman, where he realised the extent of hostilities between Jordan and Israel; when he said he wanted to travel on to Israel, he was politely asked where that country might be and informed there was no such place. Unable to leave or to telephone anyone in a country that did not exist, David rang friends in Dublin to ask them to let Ezra know about the delay, telling them he was stuck in Amman.

Thinking he was jokingly referring to sexual adventures ('a man'), his friends did not immediately understand the seriousness of his situation.

After four days, David threw a tantrum, was escorted out of the country and unceremoniously dumped on the Israeli side of the border.

The time in Jordan had not been entirely wasted. On a visit to the city of Jerash, he complimented the tour guide on the preservation of the enormous Corinthian pillars and vast Roman buildings that were quite spectacular. The guide shrugged. 'We have no coal, no oil, no steel. We have just these old buildings. We do not care for them particularly but the visitors like them.' On his

return home, David repeated the guide's words many times to illustrate the financial benefits of preserving Dublin's architectural heritage. David also accepts invitations from around the world, even China, to lecture on Joyce. 'His lecture brought the house down,' says Bob Joyce, who with his wife Joyce, accompanied David to Beijing. 'All the other lectures were translated on the spot, from English to Chinese or vice versa, but not David's. He did the sounds of Ulysses and Finnegan's Wake as only he could and the translator was struck dumb! But everyone understood. This was James Joyce at his best.'

Few of his trips were uneventful. One evening he arrived in Paris with £1,000 in cash, expenses from the European Court of Human Rights during his court case in Strasbourg, flung his bag in his hotel room and set off for the Irish bar in rue Montmartre. During the evening, David put his wallet on the bar counter and later found it in the men's room, emptied of every franc. He consoled himself with a vast amount of alcohol, woke up the next morning with a violent hangover and took himself off to visit a friend. In one room of her apartment he found a desk with a table lamp, a chair, a carafe of water and the collected works of James Joyce - the props he used in his one-man show. It appeared he was giving an impromptu performance. David gulped down a whiskey, brought it up again, then began his show.

'It was one of the best I ever did,' he recalls. 'The audience were wiping their eyes. One woman said afterwards she was so moved when I performed the death of Anna Livia. She could tell I was nearly in tears. I was, but I wasn't thinking of Anna Livia. I was thinking of my thousand quid.'

David's drinking had often caused arguments with Ezra in the past, and had now become a concern to many of his friends. 'He went through a very bad patch at one stage,' says his close childhood friend Michael Moran. 'I remember going to a party at his house once and getting

a huge fright. I thought he wouldn't last if he carried on as he was. And at the party there seemed to be lots of hangers-on. In my view they saw a huge house and they saw money. David's a terribly generous person and when he's drinking, money just comes out of his pocket because he wants everybody to be with him. I was very relieved when Patrick came on the scene.'

David acknowledges that Patrick Landers, a friend since the late seventies, was extremely kind and supportive when his relationship with Ezra fell into difficulties.

'There was nothing going on between them,' says Michael. 'He was just a very nice friend, who was very good to David and stayed very loyal. He moved into the house, stabilised his life and the next time I saw him [David] he was a different person.'

Financially David was able to be generous. He paid for Ezra's tickets to Ireland, and put money towards his mortgage when he bought a flat; and when Isaac was out of work, David regularly sent them 'the spouses' pension', extra money to see them through hard times. But just as his mother in the Congo had taught her servants to read and write, David demonstrated his compassion through practical help. 'He'd get calls from parents of young boys who were gay, or people with different sexual problems, and he had time for everyone,' says his former secretary in Kildare House, Enda Dowling. 'People were always wanting things from him and he's so kind-hearted he never refused. I would tell him he was doing too much and he'd promise to cut down, but he found it too hard to say no.'

Brendan Ryan comments: 'I think one of the things people forget about David Norris is the depth of his Christianity. He's a very, very committed Christian, in spite of, not because of, his church, and that comes through the whole time.'

Ezra has witnessed David's consistent generosity and selflessness through the years. 'David is special. I'm sure

not everyone likes him, maybe they're jealous or find him selfish or aggressive. You can't please everybody. But I don't know anybody who has good reason not to like him. Isaac dislikes him, I think because he is jealous of our relationship, but that is not an objective judgement. He has weaknesses, it took me a long time to deal with his drinking, and he's not an angel, but when you compare him to other people, I think he is a much more positive personality, all his life helping people, thinking about how to improve things. At first I didn't like his house in North Great Georges Street but I hadn't realised that David had a vision. He wanted to restore the street, not because he lived there but because he just wanted to preserve this piece of Dublin history.

'Money was never important to him. If he'd saved all his money he'd probably be a millionaire today, but he was always giving it away to help people. I remember telling him about a friend of mine who had a financial problem. David just sent off a cheque. And once, when Isaac took a trip to Egypt, he came back and told us about a group of Nigerians who were in prison there. They had been met by touts at the airport who promised them jobs in exchange for their return tickets. The jobs didn't materialise and they were arrested for being illegal immigrants. They couldn't get out of jail unless they paid a fee of $150, which of course they didn't have. David just sent the money to them, and he spoke to the Egyptian ambassador in Dublin to make sure they were released and could go home. And these were people he would never meet and who didn't know who he was. He doesn't want any credit or thanks.

'I would see him as practising the spirit of Christianity. He is good and generous and thoughtful. He's so sensitive to people's suffering, he will support them whether by money, letter, a lecture, giving a show or campaigning. I used to think he was over-generous and that he shouldn't take on everyone's problems, but that's how he is.'

One recipient of David's kindness was a partially paralysed traveller, whose extended family formed part of a gang that roamed around the west of Ireland carrying out violent robberies. Caught in the middle of one particular robbery, two members of the gang received slight prison sentences after cooperating with the police and pleading guilty. On that occasion, he had been the driver; he pleaded innocent to charges of robbery and violence, and received a hefty sentence. David had heard the story from his wife, who arrived at his office one day with their two children, requesting only that her husband be moved to a jail that was near enough for her to visit him. David, moved by the two little girls, dressed up like dolls and obviously desolate for their father, took them over to lunch in the grand surroundings of the Leinster House restaurant where he understood why she had not written for help: she disregarded the menu and asked him to choose their meal. He realised she could neither read nor write. His sense of justice offended by her story, David managed to arrange for her husband to receive a reduction in his sentence and be moved to another prison.

Judging from the amount of mail that subsequently arrived on David's desk, the family had obviously spoken glowingly of their benefactor. It seemed that every prisoner in Ireland was the victim of a miscarriage of justice.

While most people see David Norris as an outspoken, ebullient, jolly character, the tender side of his character is hidden to the general public. Joe O'Toole comments: 'Behind all that loudness is a soft, sensitive person.'

Ezra, who knows David better than anyone, also reveals the more personal man. 'He's a very, very romantic person. I don't think I've ever met such a romantic guy. I'm very dry and practical and he's the opposite, sensitive and romantic. He always sends me a huge bouquet of flowers on my birthday. It's not a duty, it's just the way he treats people, he thinks about them. I

don't usually regret things in my life but I am very sorry that I never kept his letters. It's not in my culture to collect things. But they were remarkable. He gave so much thought and time to them, choosing just the right words so that I could understand, describing what he felt and thought. They were love letters. Another custom unusual in Israel is to send postcards, but that's a habit I picked up from him. He's sent me hundreds over the years. But my postcards and letters were never the same as his. I'm lazy. I'm not a writer. I transfer information more than feelings.

'I am simple, I like to be simple, It's very comfortable to me. I'm not interested in politics, especially Irish politics, or Joyce stories. I think the best place in the world is my home. I'm out working in the day, but I like staying in. I have a very nice balcony and in the summer I glue myself to it. When David comes here he sits in the sun in his underwear. All the time, we have fun. We gossip, we're intimate. We can be naked and talk about other people's bodies and it's very funny. Not in a bad way. But when you've been with someone many years, you just need one word and for us it means a story. We know many people together and we have names for people, even in Dublin.

'I laugh when I see a picture of him in the newspaper, printing something serious, because when we are together, we are not intense. We have our own sense of humour. We are very, very silly sometimes. Farting is fun, this is life. We do not pretend.'

David and Ezra enjoy a schoolboy lavatorial humour, something which does not surprise Michael Moran. 'I don't see a problem with the side of David who laughs at ordinary basic humour, and the Joycean scholar,' he says. 'He was certainly never an intellectual snob.'

Nor a snob of any sort. Before coming to Europe Ezra had never before come across the concept of class, but says David never showed the slightest hint of superiority. 'I know he is very royalist. He is proud of the pictures in

his house of his uncle with Queen Elizabeth. But he never took it too seriously. He would never judge a person because of who their parents were. We've been to many places in the world and he treats everybody the same. He would never think that because of his education or social and political position that he was better than anyone. I think it is mainly from being gay because it breaks everything. It makes you more liberal, open-minded and tolerant. It is other people who judge him.'

And sometimes they get it spectacularly wrong. David keeps on file this letter, printed in a newspaper:

> Would somebody please tell me how Mr David Norris can come to Ireland, become a member of the Senate, and then set about changing the laws of this land of ours? We must be the softest nation in the world.

It is unlikely that the correspondent was aware of David's place of birth, and highly likely that it was supposed that David's manner of speech led the writer to the belief that he was British, a view endorsed by Tom Hyland, who laughs when David jokingly refers to him as his 'working-class friend'. Tom remembers a neighbour in Ballyfermot meeting David for the first time.

'She called me afterwards and said in surprise, "Isn't he a grand gentleman?" People just go by his voice, but I've never known him to be snobbish or look down on anyone. Nor to look up to people for that matter.'

In 1992, David was living in his house in North Great Georges Street but spending most weekends with his aunt Miss FitzPatrick, who lived in Ballsbridge. At the age of ninety-four, she was in good health and exceedingly good spirits, and was stubbornly independent, but her nephew would do her shopping and some cooking, and keep her company. Every Sunday they would go to David's cousin Susan, for lunch, a tradition that had started years earlier when Granny Wiz

was still alive.

'I used to say to Miss FitzPatrick, "I'm sure David isn't bothered about coming over," but she assured me he was. He likes to have some kind of roots and family. He'd chat non-stop, usually about his work, but he'd enjoy having a good discussion with the children. Then in the afternoon he would take his aunt to St Patrick's Cathedral.'

Visits to John and Mary, who lived in Portmarnock, were less frequent; John had built up his business as a truck driver and was travelling for much of the time. But they kept in contact by telephone, something that was occasionally a life-saver for Mary. 'With John away so much, it was lovely to have a kind and caring brother-in-law I could ring up and talk to,' she says. 'I don't go downhill very often, but if ever I was at a low ebb I would get a continuous string of phone calls from David. And there have been many occasions when his support has been quite marvellous.'

One such occasion was when John and Mary's eldest daughter, Gillian, was having an operation to remove her appendix. John was in Europe, and on her way to the hospital, at eight o'clock in the morning, Mary's car broke down. 'I just rang David, he drove out to where I was, took me back to his house, rang the hospital and found out my daughter was still in theatre, cooked me breakfast, drove out and mended the puncture, then followed me to the hospital. He's just always there for us,' says Mary, a Catholic, who kept her faith after marrying John and made sure their four children were all christened, baptised and confirmed. 'David's been there for the whole lot except one, which is better than their father who was never sure when he could get home,' she says. 'And he's wonderful with the children. He has never spoken down to them but always tuned in at their level. If they were serious, he could be serious, if they wanted to mess about, he could too. I remember if ever we were at his house when the children were young I was always terrified that they would touch and break

things. He'd say, "Mary, so what? This house is to be lived in." I think he would have made an excellent father, a fabulous father.'

It is a sentiment shared by many. Josephine O'Connell remembers David arriving at her house while she was trying to persuade her three-year-old son to eat. 'He started telling a story about a crocodile who ate another crocodile, and I can remember John's eyes getting wider and wider and the food automatically going in.'

One evening following a meeting of the street's preservation society, Josephine finally spoke her mind. 'Well, David Norris,' she said, 'aren't you the mean old thing? There you are with your good job and your lovely house and you'd never think of adopting a child.'

'It may have escaped your attention, Josephine,' he replied, 'but I'm gay.'

'And what about it? Aren't you great with children?'

David was delighted by the compliment but never considered adopting a child or marrying to satisfy any paternal instincts. 'One of the things I loved about Ezra was that he was wonderful with children. If we had been living in a permanent domestic situation, and he had wanted to adopt children, I would have been quite happy. And if I was heterosexual, I would want to have children, certainly. But to deliberately set out to have a child just to satisfy my desire for parenting - no, I wouldn't be interested in that. I think it would be a beautiful thing to have children who are the physical expression of your love for each other. But if it's not someone you love, if you're just using them in order to project your genes into another generation, then I think it's exploitative. I know some people have done it and it seems to work for them, but it wouldn't for me because there is an element of dishonesty and charade about it and I think in a very intimate relationship you need honesty. Of course gay men do get married, but the idea of a sham marriage would be terrible for me, hell on earth.'

173

David did have some heterosexual experience, however. 'I've never been physically repulsed by women. It's just that I've never had any active desire. But I know, and have demonstrated, that I'm mechanically competent in that area.'

He will never, then, have children, although he has excellent relationships with all the young people he meets. Joe O'Toole remembers David arriving at a dinner party with a male friend, armed with fireworks to amuse his five children. 'I felt sad that he mentioned it was the first time he had ever been invited to a domestic heterosexual family and asked if he wanted to bring a partner, but the kids had a great time with him. I always felt delighted whenever they visited the office and he talked to them. There's something open and refreshing about him.'

Such praise seems common to all the parents whose children know David, and his sexuality has never been an issue for them. Mary remembers David suggesting that perhaps he should talk with his nephews and nieces about being gay.

'I said, "What for? You wouldn't start explaining that you're a lecturer at Trinity. Why extract it from the whole person?" One of them did ask if Uncle David was gay, and I said he was. That was it. They accepted the overall person which is what I and David would prefer.'

But John and Mary would have no hesitation in entrusting their family to David's care. 'The guy is gay, not a pervert,' says Mary, angered by the way some people perceive homosexuals as child molesters. 'I remember hearing callers on a radio programme saying that homosexuals should not be allowed near children. I could not believe the ignorance that was displayed. I would have loved to have phoned up and said I had a brother-in-law who was gay and if anything happened to my husband and me, we would willingly leave our four children in his care. And I think that is about the highest compliment I can pay him.'

We're Here, We're Queer, We're Legal

On 30 June 1993, in what was called 'one of the historic events of the decade', the Seanad passed the Bill decriminalising homosexuality. The same laws would now apply to homosexual and heterosexual behaviour: there would be a common age of consent of seventeen years, and the same privacy codes. The previous week, the Minister for Justice, Máire Geoghegan-Quinn, had spoken of the Bill as being 'a necessary development of human rights'. She described the old legislation as 'grossly and gratuitously offensive' to gay men, and any proposal to provide an unequal age of consent was underpinned by 'a genuine lack of understanding of human nature'. The Minister for Equality and Law Reform, Mervyn Taylor, asked: 'What could be more important for us legislators than to create a climate and a space where two people who have chosen each other can express and share their love?'

The reform, which was welcomed by all sides of both Houses of the Oireachtas, was admitted as being 'long overdue'.

Indeed, David Norris had started proceedings in 1977

and it had been five years since the ruling from the European Court in Strasbourg; the then Minister for Justice, Ray Burke, had promised that within a year a gay law-reform Bill would be introduced. It was a promise that was repeated, and repeatedly broken.

'As it turned out there was nothing wrong with the delay,' comments Kieran Rose, co-chairperson of Gay and Lesbian Equality Network. 'Because we got a very good law reform which was worth waiting for, rather than rushing through a British-style law. A lot of us were quite shocked by the sense of liberation and rise in confidence the law reform brought. People could no longer rely on the law for their prejudice, and they had to accept that all the political parties voted in favour of equality. That's not to say there isn't homophobia, but it became less acceptable. If only the Catholic Church would change its policies, it would have an equally strong effect in changing prejudices.'

Coincidentally, the annual Lesbian and Gay Pride parade was held on the Saturday after the law reform. 'One would need a heart of stone not to have been moved by the great waves of happiness that surged through the centre of Dublin,' wrote Mary Holland afterwards in the *Irish Times*. Irish lesbians and gays had taken to the streets, throwing pink carnations into the crowd, walking hand in hand and chanting, 'We're here, we're queer, we're legal.' Congratulatory telegrams and messages began to arrive at North Great Georges Street. Among them a wonderful exotic plant from a gay couple in Limerick. In the excitement somebody removed the label with the address and threw it out so the gift was never acknowledged much to David's shame and embarrassment.

However, it was a satisfying conclusion to years of commitment. 'It was absolutely worth it,' he says. 'Apart from anything else, when I first realised I was gay - although the word didn't exist in my vocabulary at the time - I thought it was some kind of awful perversion

and that I was the only one. Then I subsequently discovered that there were lots of well-placed, wealthy individuals who were gay. Had they been out I would have had a positive image, so I felt an obligation not to betray the generation after me in the same way, that they shouldn't have to go through the misery and loneliness and confusion that I went through which was totally unnecessary. I felt perhaps that by being out, by being open, by campaigning and making an issue of civil rights, I would have done something in a small way to increase the general level of happiness.'

Whatever the differences of opinion within the gay community over the years, few would disagree that David Norris was largely personally responsible for the law reform and the slow change of attitude towards homosexuality in Ireland.

'It is arguable, given that anything to do with sex in this country is such a sensitive political issue, whether anything would have changed without him,' says Brian Murray. 'I suspect not. He provided the environment by which the government could change. And I've no doubt that his presence in the Senate has resulted not only in raising the issue of homosexuality but has meant that sexual orientation is one of the things which is included in legislation as a protection of minority groups.'

Kieran Rose agrees, but also points out that David's personality accounts for much of the change in perception towards homosexuality. 'Getting to know a gay person and realising they liked him has had an incalculable effect on the minds and attitudes of the people who change the laws. But really it is his general persona that has allowed people to move from their prejudice. He's respected, he's somebody people would love to talk to, have a pint with. He's just good craic.'

Within the gay community, of course, David Norris had played an enormous leadership role. Many feel, and justifiably so, that much of recent change is the direct result of his actions. 'Everybody knows who he is,

everybody has a good word to say about him,' says Brian Murray. 'On his rare public appearances at a gay venue now everybody will want to speak to him.'

And for many young gay men, such as twenty-three-year-old Junior Larkin, he is simply held in reverence. 'I grew up having to watch every word I said. I'd known my best friend since I was four and I couldn't even tell him I was gay. I come from a working-class area, Kilbarrack, and every time I stepped outside the front door people would be screaming at me, "Queer, faggot, watch yer arse, Junior's around." Sometimes I'd get beaten up. One person would start it and his friends would that feel if they didn't join in, the others would think they were queer. They have to prove they're macho men. I was very much involved in the Church, I'd go to Mass every day, and at one stage I wanted to be a Christian Brother. But after being taught to love your neighbour and that everyone is equal, the Church said, no, it's all right to discriminate against gay people. I felt let down, alienated. It actually hurt.

'I put up with this for years and with believing I was the only gay in Ireland. Then, when I was about fifteen, I saw David Norris on the telly. I was in shock. For the first time I realised there were other gay people. I really admired his courage and never thought I'd be able to come out publicly too. But David Norris paved the way for the rest of us. He enabled others to come out.

'And I remember after going on television myself to talk about being gay, the next day a middle-aged man approached me in a gay pub. He'd come up from the country. He said, "Thank you for talking about homosexuality on television," and then he started crying. I thought he must have felt exactly as I had when I'd seen David Norris on the television. Another lad told me his ma and da were watching the television then asked him if he was gay, and he was able to tell them and they were very supportive.

'These people were helped because I was on television,

but I would never have been able to do that if David Norris hadn't come out years ago. He has contributed practically everything to gay society. If there were no David Norris, there is no way homosexuality would be decriminalised at the moment, new equal-status legislation wouldn't be planned to put a stop to discrimination and make it easier for gay people to get decent jobs. He changed my life and the lives of thousands of others because, believe me, there are lots of us out there. David Norris is my hero.'

Many find it impossible to believe that Ireland, the most Catholic state in Europe in terms of churchgoing, now has one of the most liberal laws on gay rights, vastly more liberal than Britain, dramatically more liberal than Northern Ireland. There is a common age of consent - seventeen - for hetero- and homosexuals, prohibition of dismissal from employment on the grounds of sexual orientation, and possibly, in the near future, prohibition of any discrimination whatever on the grounds of their sexual orientation.

'This is a country where you could be jailed for owning condoms,' says Michael O'Toole incredulously. 'A journalist I know was accepted as an officer cadet in the Irish army in the fifties, and during inspection one morning a packet of condoms fell out of his locker. He was immediately drummed out of the army.

'It was officially put on the record of the Dáil that there was no sex in Ireland until 1961. Sexuality was never mentioned. The censorship laws were so severe that local authorities were prevented from putting up notices about sexually transmitted diseases in public lavatories. And on the first night of *The Plough and the Stars* in the Abbey, there was a riot with a woman screaming hysterically, "There are no prostitutes in Ireland", when about five blocks away was one of the great red-light districts in Europe.

'For anyone like me who grew up in the fifties and sixties,' Michael continues, 'it's difficult to believe the

changes that have happened. David has been a catalyst in that, in helping to rid Ireland of that cant.'

Mary Robinson, who must have received a certain satisfaction from her role as President of Ireland in signing the Bill into law, remembers welcoming a group of gays and lesbians to Aras an Uachtarain in 1992. 'David was with them and at the end, after I'd met the various representatives, he spoke. I thought that by that stage he would have been so secure it was no longer an issue of emotional pain personally, but clearly it was. He actually broke down. I thought all the better of him because it still mattered so much.'

However, she would not single out David's achievement in gay rights as his greatest effect on Irish society. 'I think his contribution has been all the stronger because of the broad range of his interests, all made with passionate commitment,' she says.

One of those interests was, of course, the cultural heritage of Dublin. 'You can't make sense of the city unless you understand eighteenth-century Dublin,' says Frank McDonald. 'Also, the inner city was turned into an unemployed, working-class ghetto by the voluntary evacuation of the middle classes from the nineteenth century onwards. Now in North Great Georges Street, that has been changed. There is an enclave of a community within a stroll of O'Connell Street. And David's house is just magnificent. He made an important personal contribution by restoring it and in saving number 35.'

Today that building - the James Joyce Cultural Centre - is a concrete realisation of David Norris's lifelong vision to make the writer's works more popular, especially in the country of his birth. 'There's no question about it,' says journalist Michael O'Toole. 'More than any other person, David Norris has promoted James Joyce in Ireland. I think it caused a bit of friction at first. I would say the people at University College Dublin wanted to claim Joyce as one of their own, being a graduate of that

university. And here was this guy down at Trinity College, suddenly becoming known as Mr James Joyce reincarnated, dressing up on Bloomsday and giving performances of his works.'

The James Joyce Cultural Centre at 35 North Great Georges Street was formally opened to the public in April 1994. An activity centre rather than a museum, and designed for Irish people, it stages dramatic productions, offers lectures and readings, and houses a library. Nevertheless, the overseas interest is enormous, says Ken Monaghan, Joyce's nephew, who runs the centre.

'We're delighted that visitors come from all over the world, but I find it very sad to find young Europeans or Japanese or Korean people coming here and they have all read Joyce at secondary school, while it's not on the curriculum here. For years and years he was just ignored completely, treated as a writer who should not be available, who would corrupt the minds of the good Irish Catholic people. We wanted to attract particularly Dublin people, to break down whatever barriers remain between the ordinary reader and James Joyce, to provide an opportunity for people in Ireland, whether they have little or no knowledge of Joyce and his works or a vast knowledge, to come here and learn something. I think David has broken down an enormous number of barriers in that area. He has popularised Joyce. Every time he talks about him he demonstrates not only his own great wit and humour, but the humour of Joyce - in a most unacademic way, which I believe is the essence of the matter. When you find professors or international scholars talking about Joyce, they're almost incomprehensible. They're always looking for the symbolism and the streams of consciousness or the psychoanalytical content. But David treats him as a very funny writer, a Dublin writer, who makes people laugh. And cry too. Joyce always said he would keep the academics busy for 300 years but he wanted his books read by the people of Dublin, because he was writing

about them. It is David Norris who brought that about.'
Ken is in no doubt whatever about David's role.

'I think he is fantastic, a marvellous person, an Irish
man, too, in the true sense of the word, as opposed to
even some of the characters in *Ulysses*, the "thumping the
table" kind of nationalist - he's far more a lover of Ireland
and a believer in Ireland and a supporter and protector of
Irishness than any of these. He is concerned about the
people, about the country itself, about the future, and he
takes his politics very seriously. He is a mix you do not
come across very often: the academic and the ordinary
man. He is ultra-intelligent and full of humanity. There is
no side to him; he has a tremendous perception and
feeling for people and is full of humanity.

'I can't say enough good things about him, but I think
it will be some time before his true worth is
acknowledged. Having said all that, he can annoy the life
out of me as well.'

David Norris does, of course, have faults. For a start,
he can talk too much.

'He doesn't want to hear what you have to say, he
doesn't listen, he doesn't even wait for you to finish your
sentence because he's trying to speak,' says his colleague,
Shane Ross. 'It's because he's got such strong viewpoints
on things, he literally wants to get them out of his system,
to get out what's on his mind. But also he's got a very
great sense that what he has to say is more important
than anybody else's views.'

This seems to be a common complaint among David's
friends and colleagues, and something that can be
particularly infuriating for those who attend meetings
with him.

'He just takes over,' complains Josephine O'Toole, his
neighbour in North Great Georges Street. 'I sometimes
have to tell him, "You've had your say, now it's our turn."
But the fact is,' she admits, 'he is very capable, he makes
his point and he has such control of the English
language.'

Mary Robinson is one of the few people to whom David will listen, yet she agrees that he can be overly garrulous. 'David had very strong views and was very intense, but he was a very good client because he took advice. He always demanded a kind of quality in that advice - his questions were very searching and he was relentlessly focused on the case, but having teased it out, he actually took the advice at every stage. And that was very helpful because when clients think they can second-guess and do it better, very often it can be disastrous.

'But he can also go on too long. He could be called upon to speak for five minutes after a meal, and twenty minutes later would still be talking. A good deal of it would have been funny but you would have liked a little more self-discipline. At times his tongue can run away with him, there's no doubt about that. Even in a Senate context, he would have said some things he might have regretted afterwards. And I've heard him be sharp, never really intending to be hurtful, I think. But he can be sometimes.'

That sharpness of tongue which Michael Moran had witnessed when they were teenagers, has obviously not blunted over the years.

'He has absolutely no control over his quick retort,' says Joe O'Toole. 'He can't resist the opportunity to respond quickly but I think it means he can come across as a bit hard and harsh.'

The quick-fire biting response could be a habit, developed as self-protection at an early age when David was still insecure and confused about his homosexuality, for he is shocked and hurt that others find him brutal.

'His humour is cruel, absolutely viciously cruel. He's got an instinct for people's weakness and conversationally he devours them,' says Shane Ross, who has known and worked with David a long time. 'I'm one of his best friends and the things he says about me when I'm out of the room are absolutely vicious, but I don't mind because he doesn't mean it and he's pretty bitchy about

everybody. Nobody minds because you get used to his wit, which is extraordinarily catty, and he's very, very funny.'

But that ability, or need, to entertain is at times tiresome. 'It can be trying to get him to be serious for any length of time,' says Brian Murray. 'If you're trying to organise an election campaign and have deadlines to reach, and he has everybody falling around the floor in laughter and nobody in the mood to do any work, it is just very annoying.'

Even when working on the law reform David Norris would be humorous, says Mary Robinson. 'He was always joking and sometimes it was irritating. But I knew he was deeply serious. It was his manner of expression. It was also slightly self-deprecating, not taking himself too seriously either. I found that his humour, his attitude, even his body language of a humorous sort, was mainly being sure that neither he nor anybody else was going to get pompous, so I found it a very healthy, welcome, self-deprecating kind of humour.'

It seems that even his faults have a positive basis and that any arguments with David Norris are quickly forgiven and forgotten. 'One of the most extraordinary things about him,' says Shane Ross, 'is that he's almost universally liked. It's amazing because anybody who has to fight people politically usually leaves trails of bodies lying around the place and a lot of rancour. David hasn't done that. As Brian Murray says, he's just a loveable character.'

A month after the opening of the James Joyce Cultural Centre, David Norris took early retirement from Trinity College. He had been a lecturer for twenty-eight years.

'There were times when I felt the teaching element wasn't given sufficient credit, and of course there were some irritations, like being prevented from going to an international Joyce Symposium because I was supposed to be at an examiners' meeting. But at the end of the day Trinity provided an environment in which I could

develop, and it helped shape and give me a political, intellectual and performance career, and I'm grateful for that.'

Others believe that Trinity's treatment of David Norris deserves little gratitude. 'He is probably the best-known Trinity graduate in the world,' says Shane Ross. 'They could have used him better, asked him to take trips abroad to raise money for the college. They should have just made him a professor and let him get on with his own thing.'

Brian Murray agrees that David was not given due credit. 'He stayed a lecturer for more than twenty years. For somebody of his ability, that should not have happened. He didn't have the academic standing he deserved in terms of status. I think he felt slighted by the way he was treated. He was always rather scornful about academic life, but I think in his heart and soul he would have wished to have progressed to senior lecturer earlier and perhaps to have gone on to be a full professor. But he would deny that, or that by taking the court case for legal reform he sacrificed his academic career.'

David had in fact decided to take retirement from Trinity after contracting hepatitis from drinking water on a trip to Eastern Europe. It was a sensible decision but taken only after he had visions of an early demise. Despite his obvious illness, an opportunity to take his Joyce show to Broadway had been too tempting to resist. The reviews had been terrific. Joseph Hurley of the Irish Echo wrote of the performance

'As soon as the senator's boater takes its place on the hat rack provided to support it, David Norris becomes what he so abundantly is, a brilliantly gregarious man of many parts, eager to share his love of his favourite subject which very clearly is Ireland's greatest writer ... the unpretentious Norris swung his audience from fits of giddy childlike giggles to hushed silences approaching near-vacuum proportions with the skill of a

friendly magician.'

However, on his return to Dublin David was immediately hospitalised for two weeks. On his release from hospital he immediately recommenced his hectic life, refusing to acknowledge to himself that hepatitis is a serious virus that also seriously depletes energy levels.

'I think one of the reasons they put me in hospital was to get me out of circulation, because I find it impossible to cut down,' he acknowledges.

Shortly before Christmas 1994, he was taken back into hospital for a liver biopsy. He was worried, certainly, but despite suffering from internal bleeding following the operation which caused more than a little discomfort, he was in the Seanad an hour after leaving hospital.

The next evening he lay in bed, he felt a searing pain across his chest. 'I thought this will be a nice Christmas present for my aunt, finding me dead in bed.' He took three sleeping pills, and woke up the next morning finally realising that perhaps he had been doing too much.

Christmas 1994 was spent quietly with his aunt Miss FitzPatrick - David even followed doctors' orders and cut out alcohol - but in the New Year he resumed all his activities, except teaching.

His illness and retirement from Trinity naturally raised questions about the future. Financially he was secure, with a pension, his house and income from lectures and one-man shows. The money that had been ploughed into the Hirschfeld Centre was still tied up in it, however.

'There was always a suspicion among a certain element in the gay community that I made loads of money out of it,' he says. 'But all the directors worked for nothing, which actually meant we were surcharged 20 per cent for non-distribution of profits, and I don't feel morally entitled to benefit personally, even though legally I could.'

That the recent developments there have made

Temple Bar the immensely fashionable area that it is today is, he feels, another common misconception. 'Temple Bar would not have existed without the Hirschfeld Centre, yet it [the Centre] has quite deliberately been written out of history. You won't find any reference to the gay community or the centre in any of the expensive publications of the Temple Bar Developments. But they're very much newcomers to the area. We ran fundraising campaigns for women's issues, for green issues, for environmental issues, and it was that community effort, given free of charge, which brought in the young, vital people who opened up little second-hand clothes shops, newsagents and restaurants.'

Moreover, says Frank McDonald, the Centre successfully campaigned against the destruction of the whole area for a bus station. 'And I remember when Temple Bar Properties arrived with great self-glorification for the work they were doing. After some effort, David finally managed to obtain a meeting with the managing director, went into their splendidly refurbished building in Eustace Street, up the stairs, into her office, shook her hand and said, "Welcome to Temple Bar!"'

David would like to see the burnt-out Hirschfeld Centre reopened. 'I always felt it was necessary to provide services that were non-commercial, and services for people my age who might not be comfortable in a pub full of boisterous, young people. But I think it's less and less likely now. We started in a revolutionary period, breaking new ground and that's a terrific motivator, but this generation has benefited from the work we did and accept it as normal. It isn't a battle for them. They expect to do everything on grants. Nobody is going to put their hand in their pocket again and donate £10,000 of their own money. Equally, you're not going to get a group of people prepared to give up every weekend. There isn't that energy any more.'

No decision has yet been made about the Hirschfeld's

future. David's co-directors, Brian Murray, Edmund Lynch and Bernard Keogh, are less committed to the idea than David is. Perhaps they have played their part. 'It would be nice to think we've left something as a legacy for all the years and effort we put in so it would be good if it could be reborn in some way,' says Bernard Keogh. 'And although it's easier for people to come out now and feel good about themselves, I think we all agree there is still some need for support services. I don't know what will happen.'

Brian Murray thinks that, given the state of the building, it would be too costly to refurbish it. 'And David doesn't have the energy to run that kind of thing any more, nor do the rest of us. As far as we're concerned, we made our contribution in the late seventies and eighties, and it's up to others now. I think it will probably eventually be sold.'

If a majority of the directors wished to sell the building, Edmund Lynch would be in agreement. 'But I would throw myself into the place if it were rebuilt,' he says. 'It may happen yet. If we can get hold of David to discuss it.' But as most of his friends and colleagues have found, David Norris is still so busy it can be frustratingly difficult to pin him down.

'He does too much,' says Shane Ross. 'But it's his life. He can't resist it. And he's in incredible demand. He's wanted on every television and radio programme, to open things, to speak ... He's probably more in demand than any other politician in Ireland, probably more than the Taoiseach even, who would be wanted because he is Taoiseach; whereas with David Norris it is because everyone knows he gives good value. He'll make a good speech, it will be funny, people want to see him. But I can't believe the things he does. The rest of us might be invited to do things and if we don't fancy it will throw the invitation in the wastepaper basket. David doesn't. He accepts nearly everything. If you were not very kind you would say it's because he likes people listening to

him. He likes his audience. But I think he does it because he feels a certain sense of duty, that he is public property and should do these things. It's very selfless of him.'

Shane Ross wonders, however, how long David Norris will wish to remain in the Seanad. 'The causes he espouses are less outrageous now, there are fewer shocking things for him to say. He may be leading public opinion but there are fewer issues for him to lead on. I would say political relevance wanes when you have achieved what you set out to achieve. And he has almost achieved what he wanted to. He probably realises that and I think it worries him. He also feels electorally insecure, which is utterly ridiculous, having received the most incredible vote last time, the biggest vote anybody has ever got at Trinity and probably ever will. Yet he still feels his seat isn't safe. I think he could be in the Senate for as long as he wants.'

David does want to run in the next election - he is still passionately involved in issues such as cultural tourism and international human rights.

Beyond that he continues to enjoy his dramatic involvement in his one-man shows and a production of *Side by Side by Sondheim* - a production which prompted Gerry Colgan, writing in the *Irish Times*, to say of him:

> He delivers his lines with gusto, no doubt audible in the street outside, and has a gutsy go at the one song traditionally assigned to his part - 'Leave You'. Well, if we have lost a thespian, we have gained a Senator; look for the good in it.

Staging his play about Oscar Wilde also occupied much of David's time - and, of course, he travels abroad incessantly, to give speeches, to perform, to visit Ezra, to raise money for charity. Travelling also allows him to extend his appreciation of music, art and literature.

On the Walkman that he wears habitually, like a piece of clothing, David listens to Buddhist chants, found during a visit to China; choral harmonies from Fiji;

Arabic music discovered through Ezra's influence; and classical music, particularly Chopin, played by Artur Rubenstein and Vladimir Ashkenazy.

But cultured and eclectic though he undoubtedly is, David uncategorically loathes anything that might be termed 'contemporary art'. 'I would prefer the music of Andrew Lloyd Webber to the experimental work of intellectual modern composers which is deliberately ugly and violent and anguishes the ear,' he says.

He similarly abhors much modern painting, and was appalled during a recent trip to America to read a serious review in the *Los Angeles Times* of an exhibition by a man who had filled his anus with paint which he squirted on to a canvas. A video of this routine formed part of the exhibition. 'I have to say it is not something I would relish on my dining-room walls,' he comments.

As he finds melody essential to music, lines and representation to art, so David cannot abide the lack of narrative in fiction. His reading is voracious, and at any one moment he could be reading a history of Dublin tenement life, the works of Isaac Bashevis Singer, or short stories by the Chinese translator of *Ulysses*.

'I remember someone trying to get me to read *One Hundred Years of Solitude*, by Gabriel Garcia Marquez. I said, "I've had fifty years of my own, thank you very much." But at an airport I bought *Love in the Time of Cholera*, and it was wonderful - the richness, the turbulence, the vividness, the colour, basically the sense of being alive and the ability to appreciate the lives of others.'

David has always been a lover of language in all its forms. Though he cannot recall their meanings, John remembers David inventing words like 'dinghopper' and 'morsemice'. Michael Moran says that David was responsible for starting a library for his friends when they were young, and for organising trips to the theatre.

Perhaps he will take time to write himself.

'I hope he writes,' says Joe O'Toole. 'I don't mean

interpretations of Joyce or articles. I'd like to see him doing creative work. I think there's a great novel in him. There has to be.'

Until now, David's only published work is *Joyce for Beginners*; breaking down the barriers between Joyce and the ordinary reader, it had all the qualities Ken Monaghan would admire, but it disappointed some, who felt he was capable of much, much more. Ronan Sheehan, though, writing in the *Irish Press*, found it 'lively and intelligent'.

Michael Moran remembers walking to Sandymount village with his friend when they were in their early teens. 'David said he wanted to buy sweets and a copybook because he was going to write a novel. The next day it had turned into a play because that was easier to write than a novel but I don't think he ever finished it.'

David may yet write a gay novel, which would no doubt be suitably scandalous, but there remains only one real ambition, neither political nor creative nor educational, but very, very personal.

Ezra

It was only natural that David, feeling low and tired after his bout of hepatitis, should wish to recuperate in Israel, where he could receive Ezra's care and attention, and relax in the warm winter sunshine. However, although Ezra had been genuinely worried about David's health, and was kind and sympathetic whenever they spoke on the telephone, he was not about to change his lifestyle.

Ezra's relationship with Isaac had broken up in 1992, and although deeply in love with David, he did not consider him as a partner.

One evening he decided to go to a gay bar with a young friend. 'David came round to my house, nearly in tears,' says Isaac. 'He said he needed to rest and if Ezra's behaviour continued he would have to go and stay in a hotel. I felt very sorry for him but it wasn't fair. Ezra had every right to behave that way. I said: "What do you expect? That Ezra has no social life? Why, David? Why are you torturing yourself like this? You are playing with an image." He said I was right but that he couldn't help it. He was trapped.

'I was the same. I am trying to solve the riddle. Sometimes we have so many complaints about Ezra but we are inextricably linked to him. Why? What makes him so special?

'I think what David found in Ezra is a kind of father affection, a family. David lost his parents at an early stage of his life, and even staying so much time with his aunt shows he has emotional needs to be part of a family where you can find warmth and shelter, who we can be proud of and they can be proud of us. It is a very human demand. And David regards Ezra as his family.

'And Ezra is special. You feel very relaxed with him. He is charming. He has a rare warmth. His knowledge can surprise you. It is vast. I wouldn't be wrong if I said he could have been a scholar. And he was the perfect lover. Fridays were always dedicated to sex. He had a beautiful ritual. He would prepare himself as you would for the Sabbath, showering, putting on clean, fresh clothes. It was lovely.

'But sometimes he could be a devil, to me, and to David. He didn't make enough effort with him. He never even read a novel by James Joyce just in order to be close to David or ask him questions about it. David would send him letters and postcards from around the world and I would have to lose my temper with Ezra to get him to even write David a Christmas card. And he was a son of a bitch when he cut their relationship as he did, just after announcing their marriage.'

Ezra is not unaware of the pain he caused David. 'I am ashamed of some of the things I did. I would not do those things now. But between the two of us I was never serious, and he was. And I was young and silly and didn't realise that flirting with other people wasn't fair to David. I remember the *hagirah* now [the time David had fled to Tel Aviv after Ezra had told him he no longer found him physically attractive]. It was terrible, terrible. Someone is in love with you and you are nasty to him. But you can't judge today. Things happened in a different situation.

'And in gay life the physical side is very important, muscles, hair, body, size, those kinds of details. David is physically OK, but he's not Apollo. Not that I am but

194

when I was younger I was more attractive than him when he was younger, when we met. When I said, "David, you are not attractive to me any more," I didn't realise it would hurt him very much. If somebody said that to me, it would hurt me, I wouldn't be strong enough to talk about it like David. It is silly, a pity that physical things are so important in gay life but I think there is an explanation for it. If gay people were more normal, if it was more acceptable, it would be like straight life. Not all men are Mr Muscle but they manage quite well to find someone. And if he was heterosexual, I know David would be very popular with women.

'But we're over the fighting now, we're over a hurting relationship, we are still together after all we've been through and laughing about the bad times. I remember once when I was in Ireland, we'd bought some strawberries and we had a fight because I wanted to go to a gay bar with another boy. And I threw a cup of strawberries from the top floor of his house to the garden. Now it's a joke. He says he still finds the pieces from the cup in the garden. Now we can fight, we can argue, but we know that there will be another piece, another story in our relationship. We're not worried about losing each other, unless one of us dies.

'It is an unusual relationship. David always wanted me to be exclusive. I wanted to be with him but never thought it would be possible for us to be together. In the relationship we have now, there are no rules, no convention. Sometimes people think our relationship is very unrealistic but we support each other. Our Friday-night calls are very important. It's a habit, a tradition. If he doesn't ring I ring him to see what's wrong. When we have a problem we talk to each other. And it was very important when he became sick, and he was worried, to give advice or to encourage him. I have David and David has me. We are very close, very intimate.

'But David is a straight gay, looking for a normal life, stability, a long relationship, a nest, a unit. He's so warm,

he has lots of energy, so much to give. The more normal thing is to give this energy to a family. It's like good soil and no plants. He puts his energy into activities and maybe he became addicted to it. And every obsessive thing is to cover other things. If you're busy, you're not lonely. The problem is when you go to bed and you want to have someone there and you find yourself hugging the pillow. It's very difficult.'

Indeed, without a long-term partner, one wonders whether, despite his popularity, David is not fundamentally a rather lonely person.

'I would say that he is a family man, and underneath all his confidence and exuberance he is lonely and I find that sad,' says his cousin, Susan. 'But that may also be why he is so self-absorbed, why he talks about himself so much, and why despite travelling all over the world to exotic places and meeting all these wonderful people, he still wants to come to us for his Sunday lunch.'

Although David's fiftieth-birthday party, held in the James Joyce Cultural Centre in 1994, was attended by his family, Ezra and crowds of guests, Brian Murray, who has known David for more than twenty-five years, is puzzled by how few very close friends David actually has, while his aunt Miss FitzPatrick comments: 'I don't know if they're real friends, but he has an awful lot of casual acquaintances.'

In 1995 David, when not working or travelling, spent almost all his time with Miss FitzPatrick, now ninety-seven, who, although still bright and fiery, became frail after a pacemaker was fitted in May. David sleeps at her home in Ballsbridge, prepares her breakfast, does her shopping, rushes off to meetings, rushes back to make her lunch, fulfils his many duties as a senator, pops into his own house to pick up his mail, and returns to Miss FitzPatrick's in the late afternoon to cook dinner. Evenings are invariably spent watching television together.

Brendan Ryan believes that David's devotion to Miss

FitzPatrick goes well beyond any kind of filial duty but is a sign of genuine affection, love and goodness.

David and his Aunt themselves would laugh off any suggestion of mutual affection. Theirs is a bantering relationship, full of biting words that hide a deep unspoken love.

'He loves winding her up,' says Susan. 'After he had hepatitis, he came back from China and pretended that it had been too dangerous to drink water or tea so he'd drunk whiskey the whole time, and she believed him. I think sometimes he's a bit hard on her, but maybe that's what keeps her so well, as old as she is.'

Miss FitzPatrick brings herself to admit she enjoys David's company, but not all the time. 'It's nice to have him around as the day is very long if I'm on my own. But we have lots of arguments. Very often I think afterwards I was foolish to try and argue because he doesn't listen. Sometimes there's no point talking to him because he goes his own way. At night, I tell him to go to bed and he insists on staying up. Then he'll come up and if I'm not asleep he'll sit on the end of my bed, talking. It irritates me sometimes. It depends on what he's saying. If I'm interested I don't mind.

'I don't know what his mother would have made of him,' she says, referring to David's sexuality. 'She was certainly very, very fond of him. But I think, if he were alive, his father would probably be very pleased with him and enjoy having a good laugh with him, in a quiet way. I wouldn't say I was proud of him. I don't think of him in that way, but I'm very fond of him.'

Most of David's friends and family are concerned by how he will cope with Miss FitzPatrick's death.

'It will be an impossible gap in his life,' says John, his brother. 'It will hit me too, but I have my family. He might not want to, but he would be more than welcome to come and live with us.'

If David could stop living a life devoted to others' welfare, it could mean that the time has come for him

finally to settle down, but others wonder if that is an impossible dream.

'For a long time Ezra lived his life, at least on an emotional level, regardless of David. But David expected him to wait for him every year. It was ridiculous. But somehow David believed it and I think it stopped him forming other relationships. Now I wonder if it is not too late,' says Isaac.

While David agrees that his relationship with Ezra may have contributed to the fact that he did not form any other long-term relationships, his friends also believe that David sacrificed a fulfilling personal life in the same way as he had sacrificed climbing the academic ladder during his Trinity career. 'When you're a gay activist you need a lot of energy to maintain your identity and your self-esteem, and it leaves little energy for a personal life,' says Kieran Rose. 'That would have happened to David in the beginning to a certain extent, and then being a senator took him away from the gay community. It must be very lonely being a senator and the only out gay man. I'm sure he thrives on it, but I would say it's not without its cost.'

'He's hardly a sexually active person, he never really was,' says Brian Murray. 'I always had the impression that he wanted to settle down with someone. But he never really tried.'

'It is possible that because he's so well known here in Ireland, it probably militated against the prospect of him succeeding to form a relationship with anyone,' thinks Bernard Keogh. 'It would require the other person, even through association, to be out and cope with the pressures of being public. It's a great pity because he's such a delightful person and has so much to give.'

Any partner, says Josephine O'Connor, would also have to be very tolerant, strong and willing to take a back seat. 'I don't think he realises that himself.'

In fact there has been another lover in David's life. Shortly after Ezra moved in with Isaac, David was teaching a twice-weekly course outside Trinity to help

out a friend. One of his students was brilliant. He was also stunning - tall, blond, all American, square-jawed, young, and obviously taken with David. After every class he would linger behind, engaging his teacher in conversation, first talking about general topics, then, with more courage, asking him where the gay pubs in Dublin could be found.

David was extremely flattered, but wary. He was on the rebound from Ezra and did not wish to abuse his position of authority by having an affair with one of his students, especially one who was only twenty years old. After he had been invited to dinner four times, David finally accepted.

'And I fell hook, line and sinker,' he says. Their sexual relationship lasted six months, until his lover returned to America and became engaged. He never married; it was in order to please his father, a wealthy businessman on the West Coast who still does not know his son is gay.

David had felt that he wanted to share his life with the young American; again he had perhaps built up a romantic ideal of a lifelong liaison, a dream that was unrequited. Again he forced himself to be content with a lifelong friendship. He has no regrets. 'I really loved him, so I found I could love more than one person after thinking I could only ever love Ezra, and now he's one of the most important people in my life.'

Nor has David any regrets about his relationship with Ezra. 'I was sometimes a bit unrealistic about it but I always had a feeling that it would pick up in one way or another and that in a sense is what happened. And I think in any case it would have been very difficult to be together. If I had dropped everything here, gone to Israel and it hadn't worked out it would have been awful. And Ezra said himself it would be very difficult to live with me here because there are so many demands on my time. The whole sexual element tends to fade into the background anyway to a certain extent. After twenty years it wouldn't remain the most important ingredient

in a relationship. We have a history, we've shared so much together and it's difficult to close the door on that. For either of us.

'I will never lose him, but I would love to share my life with someone. Joyce had better luck than me with Nora after meeting casually in the street. They were never parted in nearly forty years. Ezra and I have been apart more than we've been together. And while Joyce says at one stage he doesn't care if he's alone, well, I do. I mind very much.'

David's dream is to settle down with Ezra. Not yet. At forty-three, Ezra may be middle-aged and losing his hair, but, to David's disappointment, he is still attractive to others.

For now, the annual trips to Jerusalem, the holidays together and Ezra's visits to Dublin continue.

'When I go to David's house I can see many things he bought in Jerusalem. I see my life,' says Ezra. 'And when I look around my house, David is here. Everything reminds me of him. I'm not surprised we're still together after twenty years. I love his personality, I love him as a person, and the more I know him the more I like him. Not many people really know him. They see only a few sides, speaking publicly, campaigning, performing. I've seen him happy, unhappy, I've had sex with him, I know him intimately, the basic life, I know his secrets, I trust him, he trusts me, I know the glamour, and the small daily unimportant things.

'When we're much older we plan to live together in a house that we will build. It can be anywhere, I don't care. We'll put our own personality on the place.'

David's friends wonder whether it will happen. Michael Moran does not believe David will ever leave Ireland, but others can see him one day settling down with Ezra.

David has no doubts.

'I love Ezra. I want to live with him. And I'm going to. You'll see.'